THE MOMENT IT CLICKS

Photography secrets from one of the world's top shooters

Joe McNally
LEGENDARY MAGAZINE PHOTOGRAPHER

THE MOMENT IT CLICKS

by **Joe McNally**

The Moment It Clicks
Book Team

EDITOR
Scott Kelby

PROJECT EDITOR
Cindy Snyder

CREATIVE DIRECTOR
Felix Nelson

TRAFFIC DIRECTOR
Kim Gabriel

PRODUCTION MANAGER
Dave Damstra

GRAPHIC DESIGN AND
PRODUCTION
Jessica Maldonado

PROOFREADER
Jennifer Concepcion

COVER PHOTOS BY
Joe McNally
Anne Cahill

CHAPTER INTRO PHOTOS
AND GRAPHIC ELEMENTS
COURTESY OF:
Brad Moore
Josh Bradley
Christopher Morris
Pointe magazine
Dave Gales
Andrea Rascaglia
iStockphoto.com

Published by
New Riders
New Riders is an imprint of Peachpit, a division of Pearson Education

Copyright ©2008 by Kelby Corporate Management, Inc.

All photography © Joe McNally unless otherwise indicated.

FIRST EDITION: January 2008

Composed in Avenir, J.D., and Solex by Kelby Media Group

Trademarks

All terms mentioned in this book that are known to be trademarks or service marks have been appropriately capitalized. Peachpit cannot attest to the accuracy of this information. Use of a term in this book should not be regarded as affecting the validity of any trademark or service mark.

Warning and Disclaimer

This book is designed to provide information about photography. Every effort has been made to make this book as complete and as accurate as possible, but no warranty of fitness is implied.

The information is provided on an as-is basis. The author and Peachpit shall have neither the liability nor responsibility to any person or entity with respect to any loss or damages arising from the information contained in this book or from the use of the discs or programs that may accompany it.

ISBN 13: 978-0-321-54408-7
ISBN 10: 0-321-54408-0

9 8 7 6 5 4 3

www.peachpit.com
www.kelbymedia.com

For Annie, whose faith, friendship, and love make everything possible.

For Caitlin and Claire, whose love and patience for a photographer dad has been nothing short of astonishing.

Foreword by Scott Kelby

The Moment It Clicks was born during a digital photography workshop up in Vermont. We were up there shooting fall color, and it was the opening night of the workshop (I was there as a guest instructor, along with my best buddy Dave Moser), and after the other instructors had given their presentations (including legendary wildlife photographer Moose Peterson, and landscape photography hot shot Laurie Excell), Joe McNally took the stage to finish off the night with his presentation.

So, Dave and I are sitting in the back, and McNally kicks into high gear. Joe is one of the most captivating public speakers you'll ever meet, and the whole class is ooohing and ahhhhing each time a new image comes up, and he's got us laughing out loud one moment, and in tears the next. But Joe's not just showing off his work, he's a brilliant teacher and he's tossing out these incredible little nuggets—the tricks of the trade, the real "meat and potatoes" stuff—and we're all hanging on every word (and scribbling notes as fast as we can write).

Every time Joe starts a sentence with, "An editor at *Time* once told me…" or "My editor at *National Geographic* once said…" we all grab our pens because we know another nugget is coming our way. At one point, Joe is talking about lighting people on location, and he gets to that point where he says, "An editor once told me…" (I won't spoil it for you here), and then he shared something so simple—it was just one sentence, but my buddy Dave and I both looked at each other and got these huge grins, because at that moment it clicked. At that moment, a concept I'd read entire books on just suddenly, and almost magically, all made so much sense. It all came together at once. It was "the moment it clicked."

When the class was over, Dave and I were just blown away. It was all we could talk about. At one point, I looked at Dave and said, "Ya know, if all I took away from this workshop were Joe's amazing one-liner nuggets, it would be absolutely worth the $795 I paid for this workshop, because I learned more about photography in that one hour than I have in the past three years." Dave couldn't have agreed more.

The next morning, Dave and I were both still reeling from what we had learned, and I said to Dave, "I would pay anything for a book of just Joe's little nuggets—just those one-liners." That's when it hit me, I had to talk Joe into doing that book. Dave was all over it and we started brainstorming exactly what that book would look like.

What I really wanted to do was take what Joe does live and transfer it to paper, because it all works so brilliantly together. For example, in Joe's class, he throws out a nugget and then—BAM!—a photo appears onscreen that so perfectly illustrates what he's talking about that it bowls you over. Then he illustrates how he got the shot (and teaches the class how to get a shot like this of their own). It's a clever three-pronged approach, and I don't know if he does it that way consciously or not, but it really packs a punch. I wanted that same effect in book: a three-pronged approach, a triangle of learning that would be unlike any other photography or teaching book out there.

After our dusk shoot that night, I sat down with Joe and convinced him that this was the book he had to write. I told him how his quotes and images had totally connected with Dave and me, and how he needed to share his gift for teaching,

and his amazing images, with more than just the incredibly fortunate 20 people at this workshop. He needed to take it to the next level, and basically, here's what I said: "Picture a two-page spread, and on the left page is one of your quotes. One of those 'An editor once told me…' stories that breaks it down to the bare bones. Then, on the facing page is the image you use in class to bring that story home, to 'seal the deal' in their minds, and then we'll tell the back story. The story of how it all came about, what happened at the shoot, and how the reader can get the same type of shot. Just like you do in class."

By the time I was done with my pitch, we had a deal, and the book you're holding now is what was born that day during that wonderful Vermont workshop.

As we started development of the book, we learned something about Joe. He has the wonderful gift of talking to the reader just like he's talking to a friend, but apparently Joe's friends are all high-end professional photographers. For example, at one point Joe and I are talking, and I asked him about how he got a certain lighting technique on a subject, and he said "Oh, I just sparked her with a pepper" (looking at me like I would answer, "Oh, of course"). I realized then that we'd be adding a fourth element to our three-pronged teaching method: footnotes that explain what all these colorful "on the set" slang terms mean. In fact, Joe took it one step further by adding a special glossary section in the back of the book, so you can call up your photography buddies and drop some "McNally Speak" on 'em, like "I pushed in wide and popped a strobe with a tight grid and a red gel under a 12x12' silk." They won't have any idea what you mean. But very soon, you will.

We also added a special section to the back of the book that I think you're going to love, because it breaks from our four-pronged approach, and gives some real insights into the man behind the camera, as Joe shares some fascinating, hilarious, frustrating, and often touching stories of a life spent behind the lens. When I was reading this collection of stories, I could just picture Joe at the bar, after a long day shooting, sharing "war stories" with his fellow photographers, and that's why we call this section "The Barroom." It's a perfect way to wind down the book, and I think you'll really get a kick out of what he has to share.

So, that's a little history on how the book came to be, and hopefully this gives you a little glimpse into the journey that lies ahead. One that teaches you concepts you never thought you'd grasp, that challenges you to try things you never thought you would. One that takes you places you've always wanted to shoot and uncovers a side of professional photography that is as funny as it is fascinating.

Joe McNally, your guide and teacher, is not only the very best at what he does, but Joe is truly one of the most genuine, big-hearted, and downright lovable guys in the business. His passion for sharing what he's learned comes across in everything he does, and I'm so proud to introduce this one-of-kind photographer, instructor, and author to you, as his amazing images and thoughtful words take you to "the moment it clicks."

Scott Kelby
Editor-in-Chief, *Photoshop User* magazine

Acknowledgments

As I always tell young photographers, it's a business where you have to have heroes. I've got lots of them. It's a business comprised of special people, and I've been blessed to have encountered and been influenced by many of them.

First and foremost is my dad, who loaned me his range-finder camera, the family snap camera, a Beauty Lite III, when I started taking photo courses. He was a pretty good photographer and an artist who was never allowed to take those skills and hone them, given the strictures of working for somebody else for a living. He always told me, hang out your own shingle. When I started taking photo classes, I was fortunate enough to have Fred Demarest as my professor. Fred, retired now, was the chairman of the Syracuse University photo program. He was everything a professor was supposed to be; without his patience and guidance, I would never have become a photographer. Tony Golden, now the chairman, has carried on that tradition, educating and preparing many photographers, including this one, to engage in this crazed but wonderful profession.

In so many ways, former *Life* staff photographer Carl Mydans is my hero. Carl was friend, mentor, teacher, orator, historian, gentleman, scholar, and, perhaps last of these things, a great photographer. He left behind a legacy of decency and photography that will reverberate always, for all shooters. Also at *Life*, I had the good fortune to shoot for John Loengard. His influence as an editor is throughout this book.

I consider myself damn lucky to have been shouted at, cursed, and praised (every once in a while) by some wonderful editors. Without good editors, as photographers we are lost. They are our anchor, our barometer of success and failure, and shapers of our skills. Early on, I got a no-shit, straight-up version of where to go and how to shoot it when

I got there from some great wire service guys...Larry DeSantis at UPI and Tommy diLustro at the AP. Later, I consider myself fortunate to have shot stories for the *Newsweek* gang: Tom Orr, Jim Kenney, John Whelan, and Jimmy Colton.

I've bounced around the halls of many magazines, and fortunately have had a chance to shoot for some great people. Dan Okrent and Dick Stolley turned the amazing trick of being managing editors while also believing whole-heartedly in the power of pictures, a rare occurrence indeed. Barbara Henckel gave me my first job at *Sports Illustrated*. Mary Dunn and M.C. Marden were a wondrous team at *People*. John Durniak and Mark Rykoff at *Time*, Mel Scott, Bob Sullivan, Andy Blau, Melissa Stanton, David Friend, Peter Howe, and Bobbi Burrows at *Life*, and Karen Mullarkey at a bunch of places, all gave out great assignments and advice, not all of it photographic. I still shoot for *Sports Illustrated*, where Steve Fine is the DOP, and has the often thankless task of juggling budget, pictures, and the nutty timetable of sports, and he does it amazingly well. Jimmy Colton migrated to *SI* from *Newsweek* and other points, and together they are like Stockton and Malone, Montana and Rice, Mantle and Maris. *SI* has always had a group of terrific editors: Porter Binks, Maureen Grise, and Matt Ginella to name a few. Matt has now moved to *Golf Digest*, where he continues to engineer wonderful assignments and has pushed that magazine to new photographic heights.

National Geographic has always stood alone in the scope of its visual ambition and achievement. I had the amazing good fortune to be invited to shoot there by Tom Kennedy, who tolerated my early failures, and brought me along as a project. As the stories I shot there gathered weight and import, I found myself assigned to picture editor Bill Douthitt, who became my dear friend and best man at my wedding.

His lunatic ravings spice certain stories in this book, as does his exceedingly twisted sense of humor. So does his faith in photography. Lots of pictures in this book would not be here if Bill hadn't simply said, go and try it. Win, lose, or draw, Bill believes fiercely in the capabilities of the lone photographer in the field to produce significant, moving images. He defends the process, and has faith in ideas, even some of the nuttier ones I have had. The mandate to simply go out, unfettered, and find stuff to make pictures of is the greatest gift a picture editor can give a photographer.

As far as shooters go, so many heroes, so many influences. In school I wanted to be W. Eugene Smith. I devoured the work of Leonard McCombe, John Zimmerman, Gjon Mili, Ralph Morse, and Gordon Parks. When I got to New York, I encountered real pros (there is no higher praise). Guys like Danny Farrell, Jimmy McGrath, and Mike Lipack showed me the ropes at the *Daily News*. In the magazine world, I always stood in awe of Wally McNamee, Neil Leifer, David Burnett, Jim Stanfield, Jim Richardson, Alex Webb, Brian Lanker, Greg Heisler, Michael O'Neill, Bill Allard, David Alan Harvey, Walter Iooss, and Jay Maisel, to name a few. I always tell young photographers to study the work of others. It is the shoulders upon which you stand.

I bought my first Nikon camera in 1973 and, little did I know, I bought much more than a camera. Over the years, I have become part of the Nikon family, and they have been a source of strength, counsel, and support in amazing ways, including the creation of this book. People like David Lee, Anna Marie Bakker, Ed Fasano, Bill Pekala, Jay Vannatter, Joe Ventura, Frances Roth, Barbara Heineman, Lindsay Silverman, Melissa DiBartolo, Mark Kettenhofen, Bill Fortney, Sam Garcia, and Carol Fisher are the human face

of a great camera system. Nikon puts their people in the trenches with us, like my blood brother Mike Corrado. Guys like Mike are the reason their cameras are so good, and why being a "Nikon shooter" has always been something special.

Every photographer needs a support system and mine is extraordinary. My sisters Kathy and Rosemary are also my dear, dear friends. Their phone calls often start with the question, "Where are you?" Even though a bit of my life remains a mystery to them, and I am often far away in the field and out of touch, we are extraordinarily close. They are always there for me, and are far wiser than I. Their love, advice, and confidences are shelter from the storm. My friend and studio manager, Lynn DelMastro, has held together the ramshackle enterprise known as McNally Photography for 15 years now, through thick and very thin, and continues to this day to be a friend, the smart and engaging face of our business, a source of wisdom and humor, a confidante, and an astonishingly skilled producer. The list could go on. Lynn wears many hats during the course of an average day at the studio. (When did we last have one of those?) All that aside, at the end of the day, it is her deep and abiding friendship, her wit and wisdom, her love of this collective enterprise, her unshakable faith and trust that enables me to once again put the cameras on my shoulder and go out and make a picture. She is one of the treasures of my life.

About a year ago, a very atypical Tennessean named Brad Moore walked in our doors. He is an able field assistant, a computer wizard, an excellent photographer who is represented in this book, and a devotee of funny, bad, good, and just plain strange movies. He has become a fast friend to Lynn and me, indispensable at the studio,

and, at many points, the glue that has held together this book project. Much the same could be said of Ellen Price, who is the shepherdess of the Faces of Ground Zero—Giant Polaroid Collection. She has been tireless in seeking support and a repository for the pictures, which is no simple task, seeing as the collection consists of twelve 2,000-lb. crates of framed, life-size Polaroid prints of the heroes of 9/11. Her faith in the importance of these photographs will find them a home. Likewise, Allison Lucas, Chris Parker, and Meghan Long work at our studio. They share in the adventure, the wonderful and daunting process of running a very small photo business.

I have been fortunate to meet and work with some of the very best people in this business. Kriss Brungrabber of Bogen, Dan Steinhardt of Epson, Michelle Pitts of Lexar, Justin Stailey of Leica, Bahram Foroughi and Martin Gisborne of Apple, John Omvik (formerly of Lexar), Reid Callanan at the Santa Fe Workshops, Elizabeth Greenberg at the Maine Media Workshops, and Gen Umei of K & L Inc., Tokyo, all have been sources of wisdom and support. That is especially true of Sid and Michelle Monroe. They run the Monroe Gallery in Santa Fe, a wonderful repository of powerful pictures that stands astride the worlds of journalism and art. The fact that they have chosen to hang some of my work on their walls is one of the honors of my career.

Photographers often develop extended families. As I write this I am out with a wonderful part of mine, my DLWS family. Legendary wildlife shooter Moose Peterson and his wife Sharon created the Digital Landscape Workshop Series a number of years ago, barnstorming around to beautiful parts of the country, teaching shooting and computer skills. I was lucky enough to join the team of Moose, Sharon, Laurie Excell, Joe Sliger, Kevin Dobler, and Josh Bradley to share pictures and laughs in equal measure, at the same time sharing our love of photography with lots of great folks. One of them was Scott Kelby. It was in a DLWS class that the light bulb Scott speaks of in his foreword went on. We were on a lonely road in Vermont, and he said, "Joe, come take a walk with me."

When Scott asks you to take a walk with him, you go. He is genius, friend, and mentor, and he knows a thing or two about writing books. He's also got a warm heart and a generous spirit, in addition to being a heckuva good photographer. We have had many long talks about light, the language of photography. He and his buddy, Dave Moser, believe in the power of images and the importance of education. At the end of our walk, Scott gave me this very good advice. He said, "Joe, you need to write this book."

For once, I actually listened to good advice. Scott and his wife Kalebra, Dave Moser, and Kathy Siler combine to run Kelby Training, NAPP, and a whole bunch of other stuff. They, in turn, brought the project to Nancy Ruenzel and Ted Waitt at Peachpit Press. Together, these folks are a force of nature, and I consider it my incredible good fortune they swept me up in their creative whirlwind. Doing the book brought me into contact with Jessica Maldonado, a peerless designer who took my pictures and some fairly lunatic ramblings and made coherent, beautiful pages out of them. Editor Cindy Snyder has been everything you want from an editor—calm, organized, forward moving, and smart. In addition to being all of those, she has taught me a great deal about the English language along the way.

At the end of the day, nothing is possible without the women in my life—Caitlin, Claire, and Annie. Caity and Claire are becoming amazing women and citizens of the world: adventurous, smart, beautiful, empathetic, and just plain with it. I hope their often-absent, nutty photog father has shown them that it is in fact a large and astonishing world, filled with knowledge, possibilities, and difference. I hope I have helped them get ready for it, just a little bit.

And my wife, Annie...I feel her sweetness, decency, love, humor, friendship, faith, and loyalty every day, in every breath. While this book is largely about what has gone on, and pictures that have been made, it is also very much about now. I could not have written this from another place, a place different from where I am now. And that place is the happiest place I have ever been. That place is Annie.

About the Author

Joe McNally is an internationally acclaimed American photographer and long-time photojournalist. From 1994 until 1998, he was *Life* magazine's staff photographer, the first one in 23 years.

His most well-known series is Faces of Ground Zero—Portraits of the Heroes of September 11th, a collection of 246 Giant Polaroid portraits shot in the Moby C Studio near Ground Zero in a three-week period shortly after 9/11. A large group of these historic, compelling, life-size (9x4') photos were exhibited in seven cities in 2002, seen by almost a million people. The sale of 55,000 copies of the exhibit book, printed by *Life*, was part of an effort that raised over $2 million for the 9/11 relief effort. This collection is considered by many museum and art professionals to be the most significant artistic endeavor to evolve to date from the 9/11 tragedy.

Some of Joe's other renowned photographic series include:

"The Future of Flying": Cover and 32-page story, *National Geographic*, December 2003. The story, on the future of aviation and the first all-digital shoot for the magazine, commemorated the centennial observance of the Wright Brothers' flight. This issue was a National Magazine Award finalist and one of the magazine's most popular cover stories.

"The Bolshoi Ballet": This *Life* series of Bolshoi Ballet images resulted in the creation of one of Joe's most well-known images, Ballerina on the Rooftop.

"Olympic Nude Series": A highly touted series of black-and-white and color photos depicting the United States 1996 Olympic team as a series of nude figure studies, published in *Life*. The only time in the history of *Life* the magazine ran four separate covers in one month.

As a commemorative, Joe did a photo diary of New York City Opera's historic first tour to Japan as part of the World Expo 2005. An exhibit of this collection was featured at Lincoln Center.

Joe is known worldwide for his ability to produce technically and logistically complex assignments with expert use of color and light. He conducts numerous workshops around the world as part of his teaching activities, and is the recipient of numerous awards, including the prestigious Alfred Eisenstaedt Award for outstanding magazine photography, as well as Pictures of the Year International, a World Press Photo award (awarded first place in Portraits in 1997), and numerous awards from *Communication Arts*.

© Brad Moore

TO VIEW MORE OF JOE'S WORK:

www.joemcnally.com

GENERAL STUDIO INQUIRIES:

Lynn DelMastro

Studio Manager-Producer

lynn@joemcnally.com

ASSIGNMENTS & PORTFOLIOS:

Frank Meo

Commercial Representative

www.meorepresents.com

meoreps@aol.com

FACES OF GROUND ZERO-GIANT POLAROID COLLECTION:

Ellen Price, Inc.

Curator/Exclusive Representative

epriceinc@earthlink.net

FINE ART REPRESENTATION-PRINT SALES & LIMITED EDITIONS:

Sid & Michelle Monroe

Monroe Gallery

www.monroegallery.com

info@monroegallery.com

Contents

Contents continued

Da Premise

A Description of the Why of the Book

What you see on these pages is not about a particular place, people, time, or cause. It's not about one type of picture or another. It's not about sportsmen or fashion models or war or politics or the news of the day.

It's about being a photographer.

It's about the sheer joy of clicking the shutter…repeatedly! The sweet sound of the shutter and the explosion that occurs in your head and your heart when you make the shot. The deal is the shot, you know. You make the picture and you know something just froze solid in a shifting world. Something stabilized, for all time. You just hung your hat on a moment that otherwise would be gone forever, and now you can go back and take a look at that moment, be it amazing or ordinary, any time you want.

It's about your eye in the camera as the light hits just right. It's about the slight turn of your subject's face that speaks the truth. It's about holding your breath as you shoot. It's about the nerves, the joy, and the terror of wondering if you got it. And then dancing about, punching holes in the air when you know you did. It's about…the moment it clicks.

Note: If you enjoy these pages, and want to read more stories, go to www.peachpit.com, register your book, and you will be able to download an additional chapter in PDF format.

Chapter One—
Shoot What You Love

Chapter One

SHOOT WHAT YOU LOVE

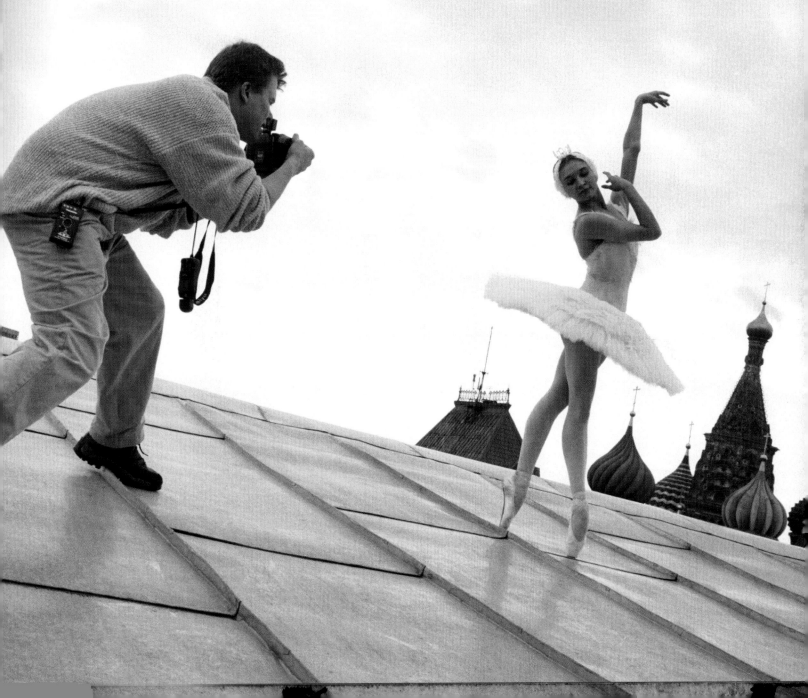

"Get your camera in a different place."

Face it, everything's been seen and everything's been shot. So how do you make a different picture—especially of changing a light bulb? Climb the Empire State Building!

As maybe Napoleon thought when he invaded Russia, what could go wrong? Plenty. Rain, fog, ice. I climbed that puppy four times and on the last climb, on the last day, I got a frame.

A bunch of frames really. When the light levels of the bulb and the skyline crossed favorably, I was just ripping film.[1] I shot 14 rolls of 36 in about 10 minutes, shooting one-handed and leveraging myself back from the antenna and up above the bulb. Time to trust your ropes!

You know, digital is a beautiful thing. Thinking back, I wish I had an 8-gig card. I changed out 14 film cassettes up there, and if I had dropped one, I'd be writing from a jail cell. Woulda killed somebody.

I waited six months, got aced out three times, have a two-inch scar in my scalp from putting my head into a girder climbing in the fog, really pissed off a bunch of TV stations in New York 'cause I threw them off the air four separate times (you have to shut down the television signals up on the antenna or the microwaves will fry you), and *National Geographic* went way over deadline waiting for the shot, but I got a double truck[2] in the magazine.

Because I got my camera in a different place.

[1] Ripping Film: Shooting bursts of photos—you just keeping shooting without ever lifting your finger off the shutter. When you do this, a roll of 36 is gone, ripped, in around seven seconds.

[2] Double Truck: A double truck is a two-page spread, and photographers love double trucks because you get paid more—more space equals more dough. It's that adage: "When you finally get it right—film is the cheapest thing you use." Pixels are free.

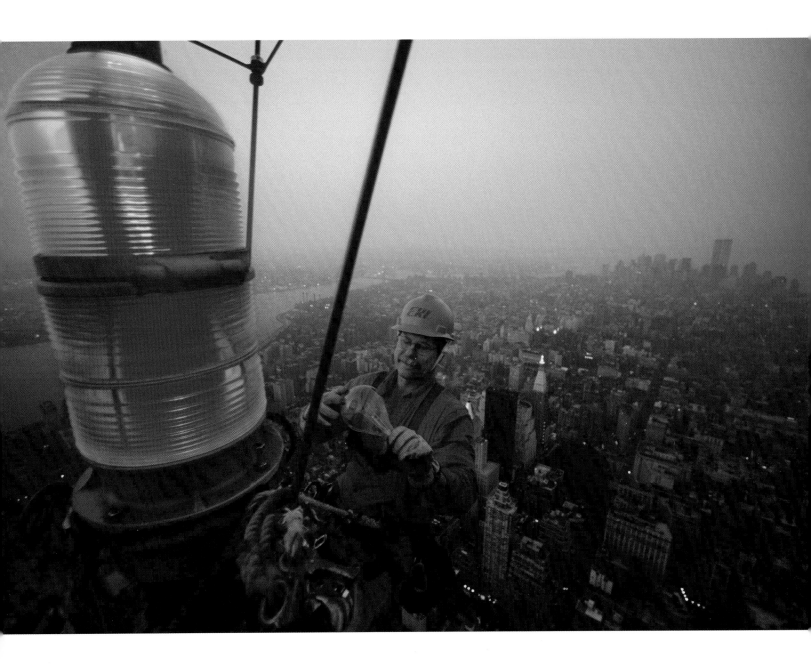

I can't tell you how many pictures I've missed, ignored, trampled, or otherwise lost just 'cause I've been so hell bent on getting the shot I think I want.

You always have to go into the field with an idea. Hopefully, a good idea. But a good idea becomes a bad idea when you don't see anything else.

So turn around. Look around. If you're shooting wide, go long. If you're at eye level, get on the ground. If you're on the ground, call for a ladder. All of these strategies generally fall under the heading, "Why don't I do my reshoot now?"

Turn around! And…if you hear music…listen.

"I can't tell you how many pictures I've missed, ignored, trampled, or otherwise lost just 'cause I've been so hell bent on getting the shot I THINK I want."

I was slogging around a C-stand[1] and a strobe in the muck of the Savannah River, when I heard a saxophone. I turned, and there was a baptism march, heading for the river in the misty dawn.

Fast as my hip waders would allow, I scrambled up the bank and grabbed a tripod and my camera, which was blessedly loaded with tungsten film. I cranked a few frames in the low light.

The bluish nature of the film played well in the pre-dawn. The slow shutter made the marchers shimmer. It was the picture of the day and the day hadn't even started.

[1] C-stand: A multi-part lighting stand with an extender arm. It's very solid and very heavy, but very adjustable. C-stand stands for Century stand, which is an old term from the movie industry from a time when these stands were generally 100" tall.

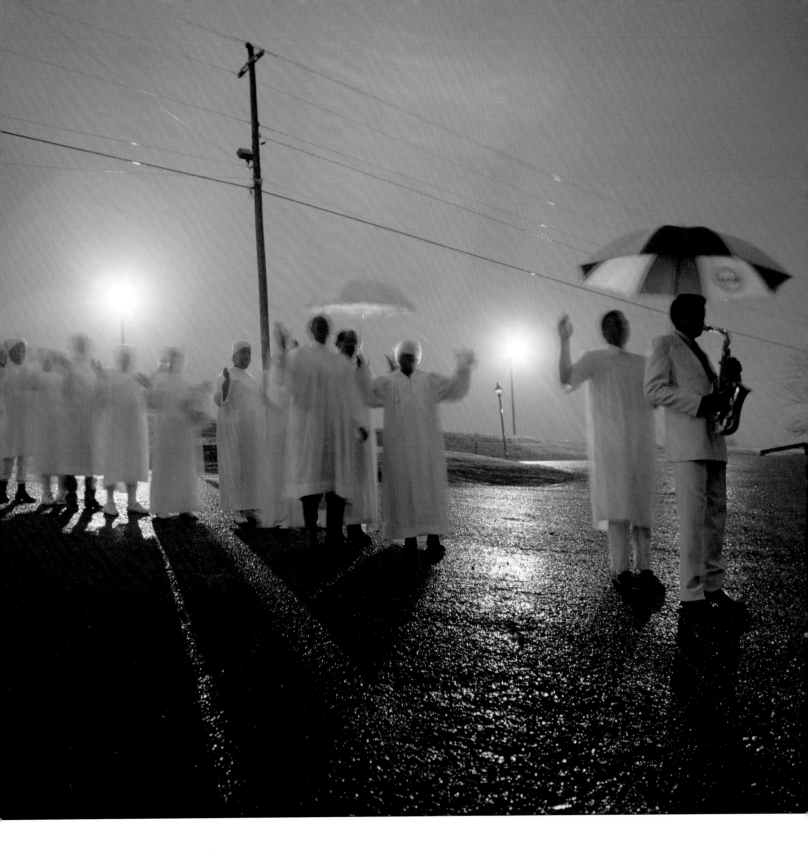

I was doing a story on Augusta, Georgia, while James Brown was still alive. He was Augusta's favorite and most famous son, so this is a picture you need, right?

Called his agent. Kept calling. Every day. For six days. Message after message. Sometimes we'd talk and I'd push as hard as I could. Got nowhere.

Then, my phone went off, and it was the agent. "If you can be in downtown Augusta in 20 minutes, James will do this picture for you."

I was like a cartoon character. I sprinted out of Augusta National Golf Club to my truck and got to the address she had given me in less than 10 minutes. That gave me 10 minutes to location scout, set up, and be ready to shoot.

Thankfully, the location was a pretty ornate building lobby. I walked in, and realized I had to make a stand right there. So I started moving furniture out into the street. (Try that in New York.)

I had no contacts, no permission, and no one to ask permission from, so I just did it. Hauled out a couple of chairs, signs, you name it. I threw up a medium softbox on a C-stand. Had no idea if that was the right light, but things get real simple when you have no time.

Had just set the light and turned around, and there he was. Purple suit, green neck scarf. He offered a handshake. He said, "Hi, I'm James Brown." I looked back and said, "I know."

The long hallway saved my butt 'cause through the far doors is bright, bright sunlight. Backlight's done! Drag shutter[1] and the whole hallway's lit. Angled the softbox over him, just barely out of frame. You can see it in the top of his ultra-cool specs. In a corporate shot, this hit in the glasses is cause for concern. With James Brown, you can get away with it.

I shot 12 frames, and he looked at me and said, "Now, I thought you were a nice man, but here you go shooting all these pictures of me." I knew the session was over. Grabbed a 105mm lens, shot a couple tight frames, and I thanked him.

The Godfather of Soul! He was dead a few months later. This just might have been his last formal portrait.

> "I had no contacts, no permission, no one to ask permission from... things get real simple when you have no time."

[1] Dragging Shutter: Want more detail in the background when using flash? Use a slower shutter speed (known as "dragging the shutter"). This leaves the shutter open longer and gives you more ambient light.

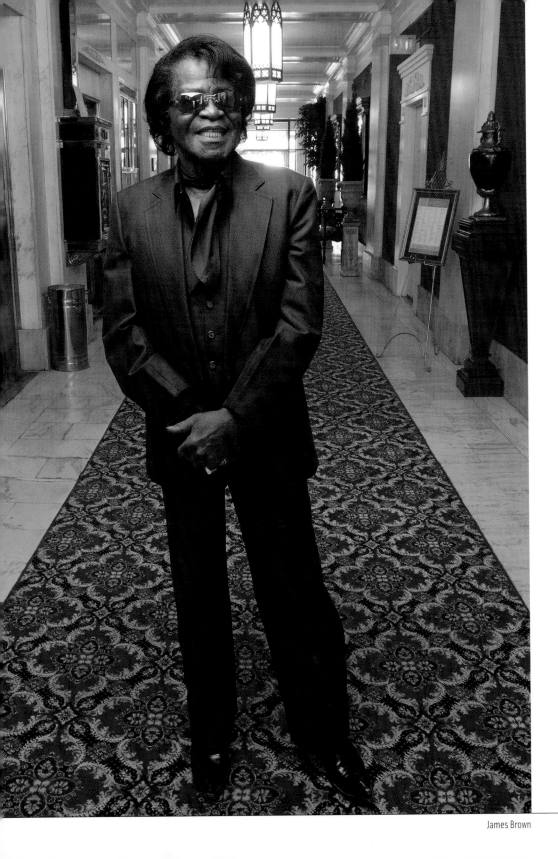

James Brown

"Tom Kennedy, the former DOP at National Geographic, always used to tell me to Pay attention to the small pictures."

Tom Kennedy, the former DOP[1] at *National Geographic*,
always used to tell me to pay attention to the small pictures.
They are the connective tissue that holds together
the larger bones of the story.

On the story about ballerina Paloma Herrera,
I had done grand, beautiful, soaring, magnificent.
She was all of those, to be sure.

What I hadn't done was a detail. Something small, intimate, telling.
Hard to blame me for this, really. I mean, when you're assigned
to photograph the Concorde, do you shoot the landing gear?

Beauty and pain go hand-in-hand—especially in the world of dance.
Paloma wasn't happy about it, but I asked her to take off her shoes
at the end of a workout. Her feet were a mess. I shot it flash-on-camera
in about a minute. Not the best, nor the prettiest picture of the take,
just the most important.

How to Get This Type of Shot: I mentioned that I took this with on-camera flash—I swiveled the head 180° straight upward and bounced it off the high ceiling of the dance workout room. Having that flash head aiming straight up fills in just enough—it's still a primarily available-light photo, it's just that the fill flash improves the quality of what you can see.

[1] DOP is Director of Photography. He's the guy that controls my air supply—he assigns the story, has control over the overall direction of the photography, and is the main tap. Everything flows from him.

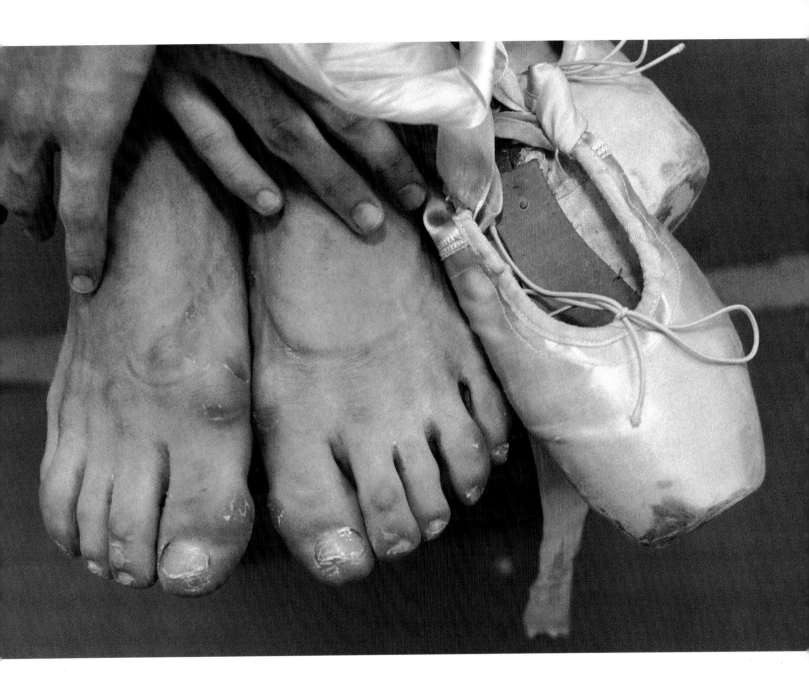

Paloma Herrera's Feet

With major athletes, five minutes is a big deal. This picture I shot in about three minutes, and got a total of 17 frames. Because of his size, I put El Guapo (reliever Rich Garcés) in the middle with Pedro Martinez and Manny Ramirez on either side. Then I told Manny and Pedro to pull El Guapo's ears, which they were more than happy to do. I got a reaction, got a picture, and they were gone. Play ball!

If you've only got five minutes, you've got to force an emotional response from your subjects that in turn will translate into an emotional response from your viewer. Humor is one of the biggest things you've got in your bag of tricks—if you can introduce a little humor into your photo, so many things can go to hell in a handbasket, and you still get a great picture. In public, these guys have got their game faces on, so when you capture them laughing, it makes them more human to the reader.

How to Get This Type of Shot: I took this using one Elinchrom Octabank[1] with a strobe positioned to the right of my camera, with the height just above the eye line to get some light up under their ballcaps.

"It doesn't matter if it's only five minutes, as long as it's the RIGHT five minutes."

[1] Elinchrom Octabank: A large softbox, slightly over 6' wide. A source of very soft, reflected light. An industry standard for both studio and location portraiture.

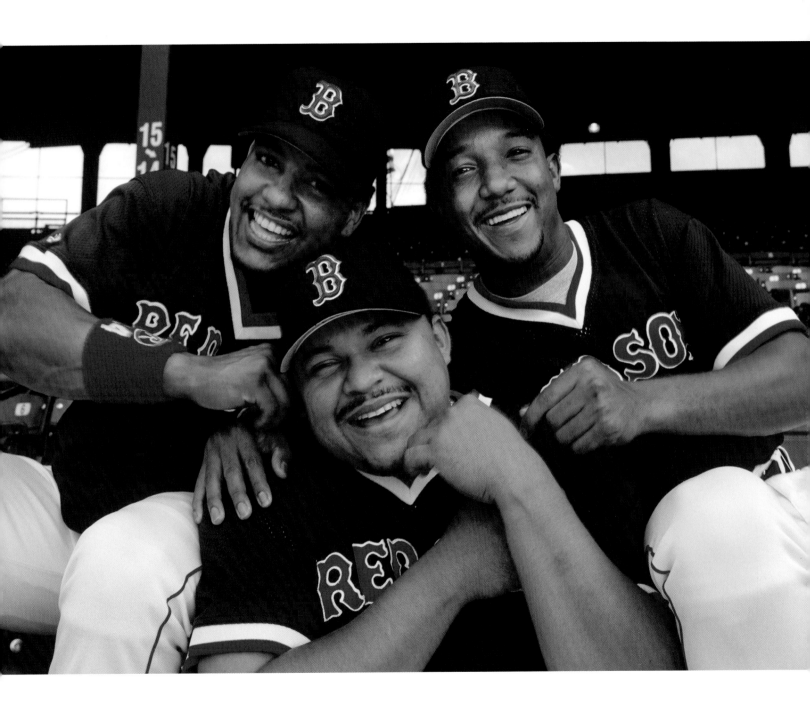

Manny Ramirez, Rich Garcés, Pedro Martinez

"Light falls.
 Just make sure it falls in your favor."

You don't want the reader to look at your pictures and say, "Well, he must have the light over here!" No. You want the reader to simply say, "Whoa, cool picture." You don't want them looking up the sleeve of the magician.

One of the dead bang giveaways occurs in a full-length picture when you don't gradate the light. You put up the light on camera left, for instance, make it all nice, and the subject looks nice and the ground looks nice too, 'cause it's lit up with the same intensity, feel, and f-stop as the subject.

Bad move. Being careless like that creates an off-ramp for the reader's eye to exit your photo.

How to Get This Type of Shot: Take the time to do the following:

A) Raise the lamp head so most of the light blows past and over the subject and disappears into space.

B) Hit the subject with a hard light you are controlling with a spot grid or a barn door.

C) Take anything you've got (a piece of black paper, a cloth, your winter jacket) and skirt the bottom third of the umbrella or softbox, knocking the stuffing out of the f-stop in the lower part of your frame.

That way, the light falls naturally down the subject's body and you don't light the ground. Light falls. Just make sure it falls in your favor.

Besides, do you really want to light her toes?

Don't pack up your camera until you've left the location.

I spent three days photographing Linus Pauling at his house in Big Sur and came up with some reasonable—but hardly exciting—pictures. Came time to leave and I had a Nikon FM2 still out, Kodachrome loaded, and a 20mm lens sitting on the front seat of the car.

Linus went to open the gate, and one of his frisky kittens scampered up the fencepost and onto his shoulder. I nearly broke my leg charging the scene. I got three frames before the cat got bored (or freaked out by my lunatic charge). I had the lead to the story just seconds before I was about to leave.

The fog turns the light into a softbox, so I shot it with just straight natural light.

"Don't pack up your camera until you've left the location."

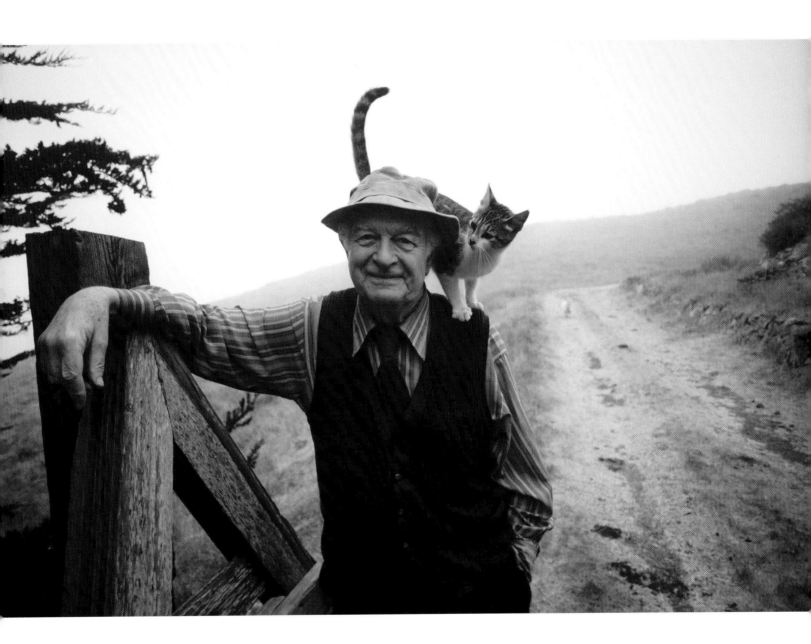

Linus Pauling

"Shoot it now.
Don't ever assume
you can do a picture 'Later.'"

Don't think you can come back tomorrow and get it. Won't happen. Light won't be there, subjects will have second thoughts, and there'll be a parade right where you want to shoot. Don't ever assume you can do a picture "later."

I was doing a mood piece on the nutty disparity between the pomp, wealth, and circumstance of the Masters golf tournament and the hardscrabble town it calls home— Augusta, Georgia. Face it, the place doesn't get its nickname, "Ugh-usta," for nothin'.

One of the dismaying things that happened in the history of the Masters was when the PGA ruled that the golf biggies could bring in their own caddies and not use the local, mostly African-American, course caddies. The locals lost their biggest payday.

The old caddies tend to gather around a hole-in-the-wall place called the Sand Hill Grill, which has a painting of an Augusta National caddie on the side of the building. I was with Hop and Mark, two old Masters caddies. They had been tough to run down on the phone, and even tougher to find in person. I needed this picture. It was getting dark out.

I asked if we could meet the next day at sunset. "Sure, yeah, okay…." Both were nodding and looking off.

No way that was gonna happen. I dragged my lights out, and shot it right then and there.

Did I want to shoot at night on a dark street corner? No. But I needed this picture. I got lucky. The grill door opened and there was a guy at the bar.

Shoot it now.

How to Get This Type of Shot: I shot this with one light source (an Elinchrom Octabank[1] with a Ranger unit[2]) to the camera's left, out in the street, about 20 feet from the subjects. I needed a big blow of light to cover the area. There's no artistry to this light—it just covers the street corner. The only camera trick I pulled here was to drag the shutter to get detail inside the grill, using a slow shutter speed like $\frac{1}{8}$-second. If you don't drag the shutter, the all-important interior of the bar goes away—and so does the picture. I have frames with the door closed and frankly—they suck.

[1] Elinchrom Octabank: A large softbox, slightly over 6' wide. A source of very soft, reflected light. An industry standard for both studio and location portraiture.

[2] Ranger Unit: An 1,100-watt-second, battery-operated flash unit. Great, dependable location strobe system.

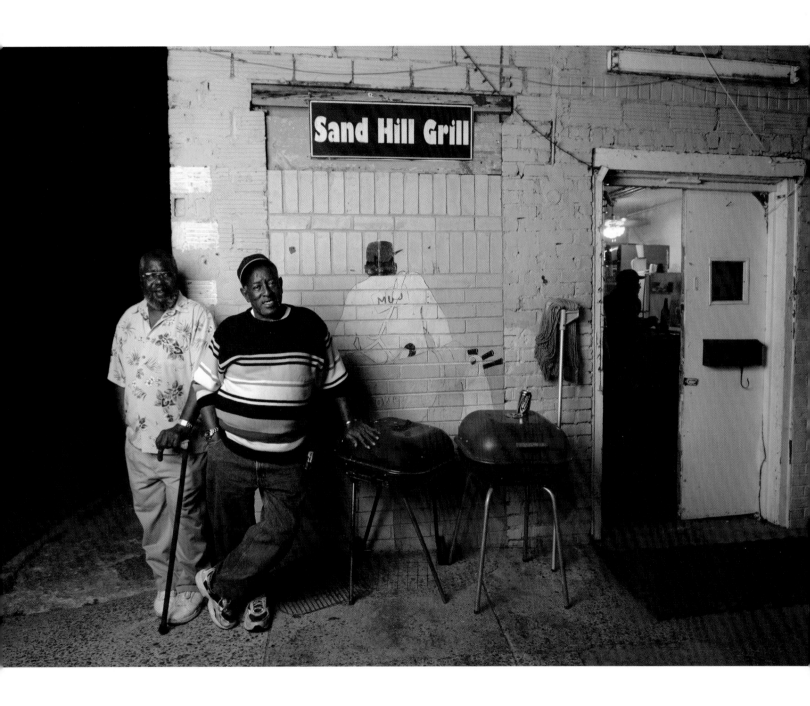

My first *Life* cover resulted from the tragic death of America's muppeteer, Jim Henson. He died needlessly, of pneumonia of all things. It was a sad story.

The one bright moment was my daughter Caitlin, six at the time, started to realize that her photog dad actually did this sort of cool thing. While other dads were driving buses, or selling stocks and bonds, or listening to suits drone on at board meetings, her dad spent the day with a talking frog.

She brought the magazine into school for show and tell and told everyone, "My daddy took this picture. My daddy knows Kermit."

So, if my editor hated the shot, at least I knew a bunch of six-year-olds loved it.

Which was good, 'cause I was very nervous about this job. Sounds crazy, right? Why be nervous? I mean, Kermit's a puppet.

When Kermit shows up, though, he's got an entourage that would put JLo to shame. He's got handlers, groomers, animators, and art directors. Also, because it was a cover, *Life* showed up with a bunch of opinionated folks.

So it wasn't just me and the frog having a little chat. There were lots of folks on the set, almost all of them over the top emotionally because of Jim's death. I had to light the job, shoot the job, but very importantly, I needed to manage the job.

Ya gotta keep your head on straight and remain confident behind the lens in a deal like this when everybody thinks you should shoot it their way.

Jim's director's chair was a given. Kermit perched on it with a soulful, sad expression. Huh? I swear, before this job I would've just thought a puppet is a puppet is a puppet. They're not alive, so their expression doesn't change. I couldn't have been more wrong.

The muppeteers kept hovering, tweaking a finger, turning the head, bending a knee. I kept hearing, "Focus the eyes, focus the eyes." They would respond to that by grabbing Kermit's head and shaking it slightly, refreshing the position, and then walking away and looking back at him.

Dang! They would do this and I swear the little green guy would look better, more attentive, more emotional. It was amazing.

So, deep and dark and moody might be the way to go for a "sad" cover. But darkness can run counter to the purpose of the cover, which is selling the magazine. Magazines sit on the newsstands with hundreds of their competitors, every single one of them screaming for attention. You've often got to light one of these puppies not in the way you might like, but in a way that is going to pop and grab the attention of the harried commuter as he or she rushes past, giving each cover, oh, about a nanosecond's worth of their attention.

How to Get This Type of Shot:

I got a little cover pop with a hair light. I used a spot grid on a strobe boomed above and behind Kermit. It rims him out, and gives him some snap. Another one creates the background highlight. Kermit himself is lit with one, mid-sized overhead softbox, lighting him but having enough sharpness and punch not to flood my little amphibious buddy with light, instead creating a highlight/shadow ratio that is very clear and defined.

Throw a very tight, gridded light source on Henson's name, highlighting it just a little, focus the eyes, and you have a melancholy Kermit that will hold its own on the newsstand.

"Ya gotta keep your head on straight and remain confident behind the lens in a deal like this when everybody thinks you should shoot it their way."

"Keep pushing.
'No,' is ALWAYS the easiest answer."

You have to keep asking questions on location.
How does that work? When do you do that? Any-
thing at all relative to this story that could possibly
be pictorial in nature? Scientists are the worst. Their
first response is generally, "Well, you can photograph
me at my computer. How about that?" Then, during
the day, if you keep pressing, they'll say, "Oh, by the
way, we're going to blow up a tank with the world's
most powerful laser in a test chamber down the
hall in a couple of hours. Would that interest you?"

Nahhhh! Let's stay here at the word processor!

Keep pushing. "No," is always the easiest answer.
This picture is the inside of the test chamber at the
National Ignition Facility in California, destined to be
the world's most powerful laser. It was sealed up and
they didn't want to take off the covers. Understandable,
as they each weighed several tons and you needed
a crane to remove them. They said, "You can
photograph our computers!"

I said, "Take the covers off and let me inside, or I'm
not coming." They took two covers off. I dropped
a light through one. One strobe pop filled the whole
blessedly reflective chamber. Dropped myself through
the other. Shot it wide. The picture ran double truck[1]
in *National Geographic*.

[1] Double Truck: A double truck is a two-page spread.

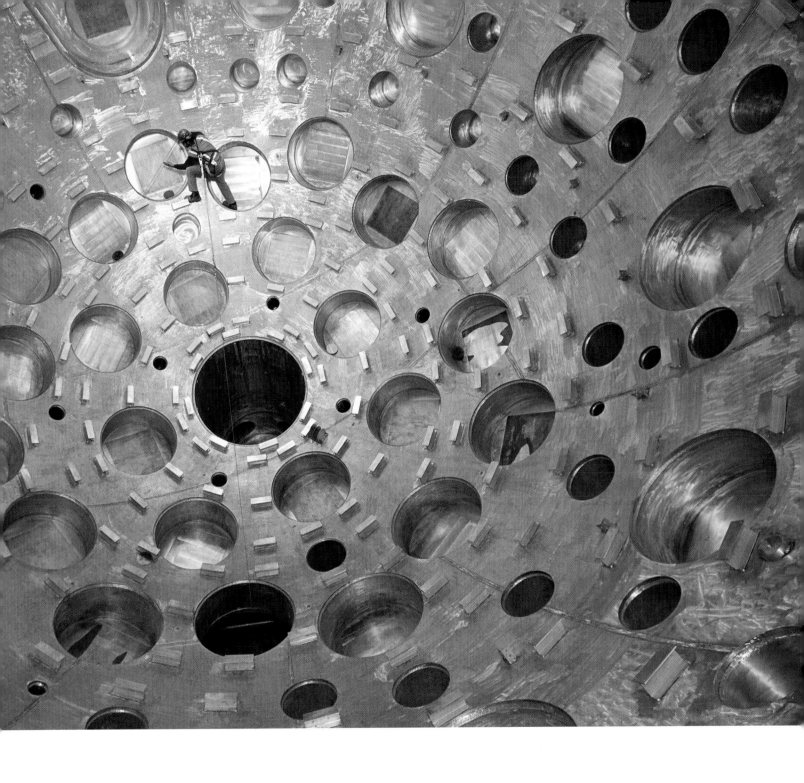

"Shooting an Olympic athlete, on skis, on the edge of one of the most famous buildings in the world should be enough, but it isn't.

You still have to take the next step."

I had a magazine assignment to do a tongue-in-cheek look at the U.S. Winter Olympic Team, so I tried to find humorous or unusual situations in which to place the athletes. I always had a good relationship with the people who run the Empire State Building, so I asked if I could put a skier at the edge of the building. Surprisingly, they said yes.

We're about 100 stories up and the wind is just howling, so it's not the time for an umbrella or a softbox. I took a strobe (a raw light), positioned it to the right of the camera and put on a honeycomb spot grid[1] so the light wouldn't spill over everything.

You'd think it would be enough just to put her at the edge of the building, light her, and call it a day. When you're looking at a truly "big picture" like this, as a photographer, it's easy to forget about the details—but it's those small details that will make the shot.

Look at the window to her left. Imagine the same photo if that window was black. It might just be me, but I hate to see a "dead" window in a photo. By putting a little light into it, the window comes alive and the picture has more depth. So I put a strobe head in there covered with a blue gel (I used blue because I thought blue would be a color that would naturally be there—plus I thought it worked well with her orange suit).

Once the lighting was in place, we put her in position, waited for dusk, and shot very quickly. It's attention to little details, like that simple flash in the window, that take the photo to the next level. It wound up as a double truck in *Life*.

[1] Honeycomb Spot Grid: This is a new cereal from Kellogg's (just kidding). It's a circular metal grid (that looks like a honeycomb) that goes over your strobe head and limits the spread of the light. I use these when I want to concentrate light in a particular area and not flood everything with light.

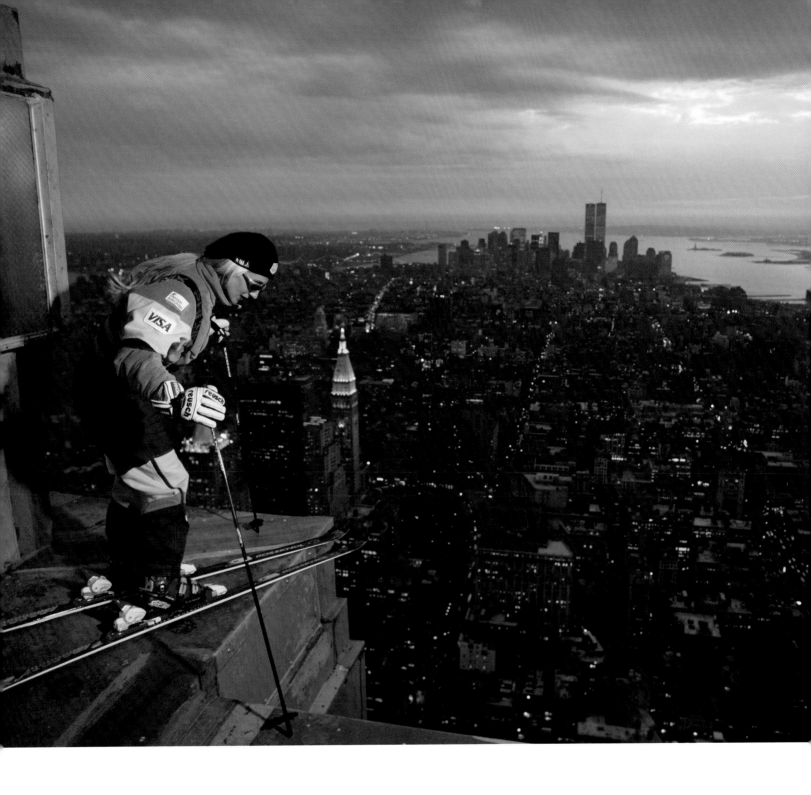

Donna Weinbrecht

You have to have faith in your ideas, 'cause the next thing is you're on the phone with a celebrity's agent telling him you really think it's a great idea to take the star and dangle her from a wire below a helicopter 500' in the air over the Hollywood sign.

If you're not passionate (and rational sounding), the next sound you'll hear is "click."

I was shooting a story for *National Geographic* called "A World Together," and I needed to show the impact Asian actors and actresses were having on mainstream Hollywood movies. I wanted to work with Michelle Yeoh. She got her start in Jackie Chan flicks and went on to become a Bond girl, and starred in *Crouching Tiger, Hidden Dragon*.

For the first shoot, I really did the Hollywood thing. I flew her out to a dry lake bed outside of L.A., got hair, make-up, and styling, the whole nine yards. Shot some lovely pictures, but my ever-direct editor at *National Geographic* basically told me they didn't mean $#!& in terms of the story. He was right.

While we were out there, we tried an impromptu stunt from the helicopter. We stood on the skids, 150' in the air, no wires or safety belts. Shot didn't work. I was too close to her. But she proved to be beautiful, daring, and fearless. It got me thinking, always a dangerous thing.

Why not fly her on a wire off the chopper over the Hollywood sign? A shot that says, "Stunt actress. Hollywood," all at once. Her people said no. She said yes.

I called my editor to explain. In between gales of laughter, punctuated by "you must be joking," he said I could take a look. I would've usually just gone ahead. This time, I knew I needed permission. He was shocked. "I'm surprised you're not calling me from the chopper, Joe," he said.

Off we went. It was complicated. We needed FAA approval, a temporary helicopter base in the Hollywood Hills, the best stunt chopper pilot in L.A., the chief safety rigger from the movie *Titanic*, and an insurance policy that basically indemnified everyone living in L.A.

We got rigged and the chopper lifted off, slowly. Michelle and I walked underneath it, and we went flying. She was graceful and daring. We got a break with the light. The key to the picture was flying with her. I didn't want to work long lens, ship-to-ship. I wanted to be right there and shoot wide-angle to retain the sweep and sharpness of the Hollywood sign.

When we landed, she laughed and told me, "You know, I'm scared of heights. I just don't look down."

The shot opened the *Geographic* story and got lots of comments, mostly from my colleagues who, after seeing me dangle on a wire from a helicopter, advised me to lose some weight.

"Why not fly her on a wire off the chopper over the Hollywood sign? A shot that says, 'Stunt actress. Hollywood,' all at once. Her people said no. She said yes."

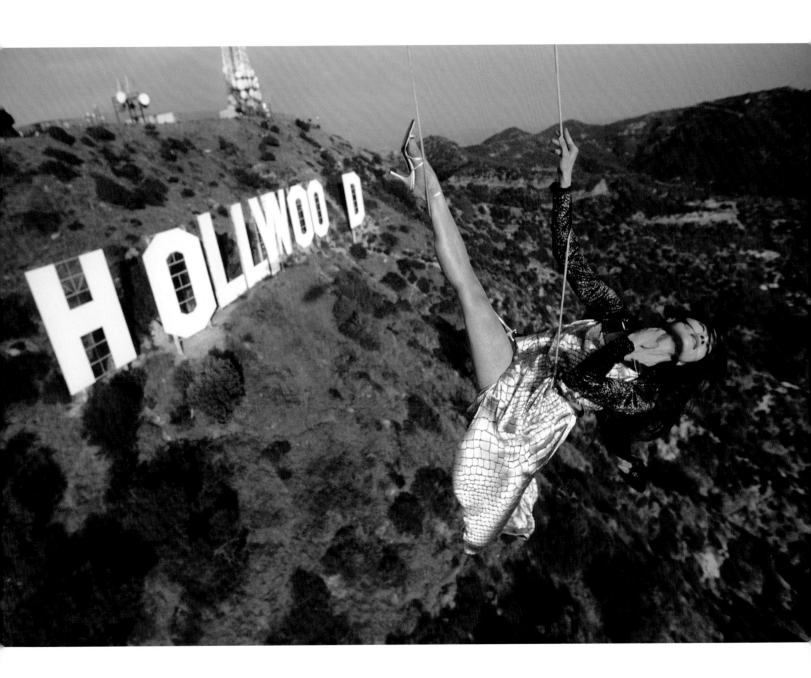

Michelle Yeoh

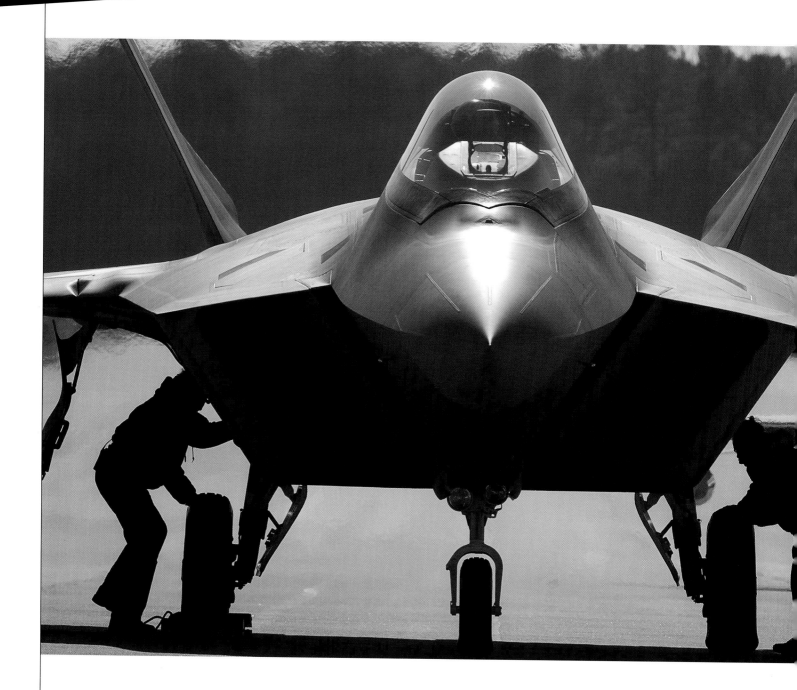

Jay Maisel always says to bring your camera, 'cause it's tough to take a picture without it. Pursuant to the above aforementioned piece of the rule book, subset three, clause A, paragraph four would be…use the camera.

Put it to your eye. You never know. There are lots of reasons, some of them even good, to just leave it on your shoulder or in your bag. Wrong lens. Wrong light. Aaahhh, it's not that great, what am I gonna do with it anyway? I'll have to put my coffee down. I'll just delete it later, why bother? Lots of reasons not to take the dive into the eyepiece and once again try to sort out the world into an effective rectangle.

It's almost always worth it to take a look. At the Lockheed plant in Marietta, I was told an F-22 Raptor, one of five flying at the time, was about to take off. It was the hot plane in the skies, still in test phase, so of course I said yes.

"Sometimes it's all working for you and you still miss. Other times it all sucks and you get a terrific frame. You just never know. The one surefire way to get nothing is to not bother looking."

I walked out onto the blazing tarmac at high noon, accompanied by a corporate shooter who kept assuring me I would get nothing. It's bad, no, make that horrible light. It's backlit. No color. We're not going to get close to the plane. There was a whole litany of reasons why I shouldn't bother. Every one of them was accurate.

I got one of the best pictures of the story, a shot that, for a time, was the best-selling cover of *National Geographic*, and ran inside as a double gatefold.[1]

Sometimes it's all working for you and you still miss. Other times it all sucks and you get a terrific frame. You just never know. The one surefire way to get nothing is to not bother looking.

By the way, the negatives about this picture were very real. I had bad light, no color, and couldn't get close to the plane. What saved the shot was a 400mm lens. A long lens gives you compression, power, and distills the essence of the frame by isolating the center of interest and dropping out the background. All I had going were the graphics of the scene and the lens nailed them. Shoot this with wide glass, the picture goes away.

[1] Gatefold: Fold-out page in a magazine that makes a two-page spread a three-page spread. A double gatefold, or double gate, is four pages across. Requires the photographer to make a long, skinny picture.

"The umbrella approach (appropriate for some instances, absolutely) scatters light everywhere. It's indiscriminate, kind of like carpet bombing."

Any idiot can put up an umbrella. One of those is writing this book. Done it plenty of times. Put up the old brollie and everything looks nice. Which may mean that everything looks nice, or that everything looks okay, which means everything sucks. Follow me?

Nice is *nice*, but it stops way short of fabulous. There's the issue of control. The umbrella approach (appropriate for some instances, absolutely) scatters photons everywhere. It's indiscriminate, kind of like carpet bombing.

So what if something in your picture's got to look one way and something else has to look entirely different? Ahhh, there's the trick! Put the umbrella away and go for the small softbox or the honeycomb spot grid.[1] Throw in a homemade gaffer tape snoot[2] and some black wrap, a few black cards to cut wall bounce, and now you're cooking.

This picture of the amazed baby was made with lots of black lining the walls, soaking up stray light. It's a double exposure, with a focus shift between the baby and the ball. You can do that on a set like this, when there's a lot of dark area.

The whole idea was to show how babies register moving objects. So I needed: (a) a relatively astonished baby, and (b) a moving object. *In one frame.*

How to Get This Type of Shot: For the colorful Nerf ball, I used a tungsten bulb for the trailing motion effect and the repeating flash mode (for stroboscopic effect) on small Nikon flashes. Those little guys were snooted in black tape to minimize light splashing about. The problem was the non-cooperative Nerf ball. Couldn't control a real-time bounce.

Solution? More black! The place had venetian blinds, so I grabbed one of the plastic controller wands off the window unit and wrapped it in black tape. Jammed it into the back of the foam ball. The off-camera assistant then held the wand and controlled the flight of the ball. Boink, boink! Perfect trajectory every time.

Made the ball part of the picture, then shifted focus to the baby. Sat him down at the makeshift plexiglass table. He leaned forward and immediately went to sleep.

But he woke up a bit later and stared up into a small softbox with its edges draped in black to control light spill. I dangled a squeaky toy, and the next thing you know, one astonished baby!

[1] Honeycomb Spot Grid: A circular metal grid (that looks like a honeycomb) that goes over your strobe head and limits the spread of the light.

[2] Snoot: Any device that forms a tube around your light source to funnel it and make it more directional. Could be a fancy Lumiquest store-bought snoot, or just some cardboard taped together. The function is to direct the light and control spill.

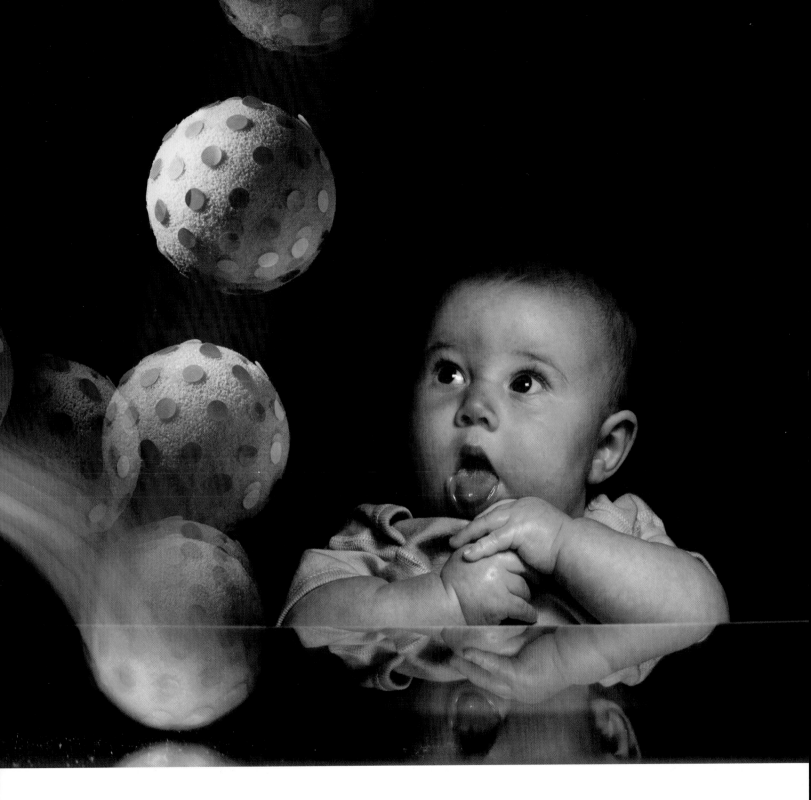

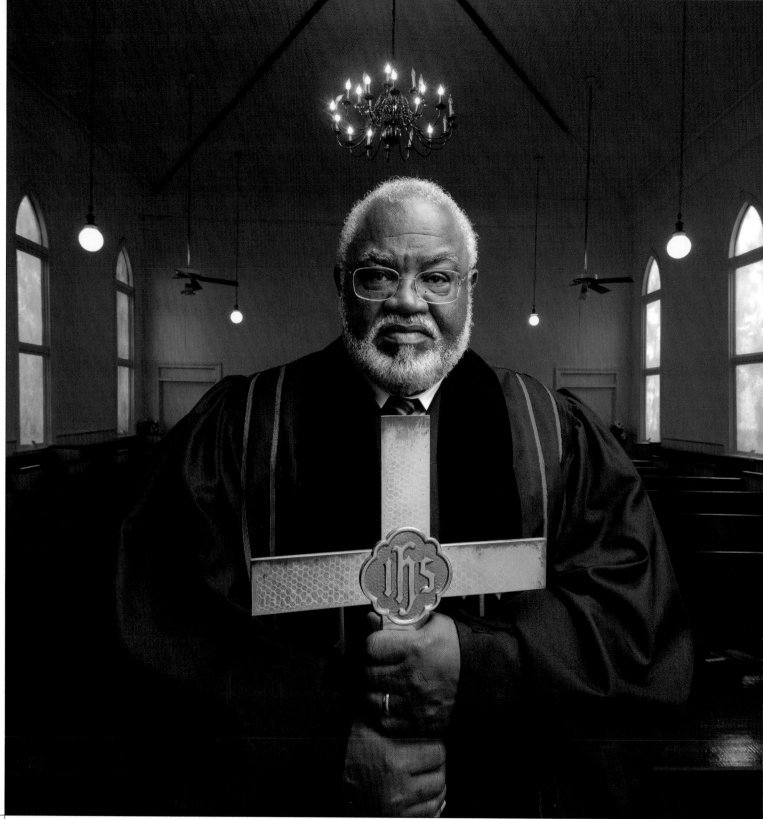

"Some rules are good ones, like the rule of thirds. It works. But, like all rules, ya gotta break it every once in a while."

I was shooting in Augusta, Georgia, for *Golf Digest*. While wandering in a pretty poor neighborhood, I noticed a group of churchgoers. I walked into church with them and immediately liked the simplicity and strength of the place. I asked to meet the minister.

Pastor Grier and I sat and talked. I explained the story. He agreed to be photographed.

The pastor is a kindly man, but formidable looking. (Check out the size of his hands. I would not want to be a sinner in this minister's congregation!)

How to Get This Type of Shot: Simplicity is best here. I put the minister right in the middle of the frame, where he would radiate authority. I lit him with one softbox overhead, just out of frame. The key to the picture is his hands holding the cross. I took a hot shoe flash, a Nikon SB-800 speedlight, and popped it into a small gold reflector, hand-held by my assistant. It was just a tiny bit of warm light, but it made the cross glow.

By the way, the halo-like fixture in the ceiling just over his head is not an accident.

BULLSEYE!

*"You gotta be loose, like a boxer—
you have to bob and weave and slip and slide.
The world doesn't stay still. We can't either."*

Technology is a wonderful thing and I love today's zoom lenses. Can't live with-out 'em. But…the dark side of all this techie stuff is that we get lazy. Lots of photographers show up, stuff their tripod into the ground like they just struck oil, and work the zoom ring like it's a knob on a freakin' transistor radio. They have all the energy and mobility of a house plant.

You gotta be loose, like a boxer—you have to bob and weave and slip and slide. The world doesn't stay still. We can't either.

How to Get This Type of Shot: When you're using a zoom technique like the one shown here, zoom from telephoto to wide. You pick up depth and sharpness, and when you're moving the lens elements during the exposure, you can use every bit of those two things you can find.

Get your hands on your subjects. Alfred Eisenstaedt, famed *Life* shooter, had a brilliant, simple strategy. He would stop the shoot, ask permission, and approach the subject. Then he would fuss over them—straighten a lapel that didn't need straightening, pick off imaginary lint, brush away a wayward hair or two the camera wasn't gonna see anyway.

He wasn't doing anything practical. The subject would look the same after his primping session. But…he accomplished something very significant: he got his hands on them.

He broke down their defenses. He got up close and personal. They allowed him to touch them, the beginnings of trust. And he got a very positive interior dialogue going in their head. "Oh, I see. He wants me to look good! He's on my side! Okay, he's not the enemy."

Try it. Then watch your subjects start liking the camera a whole lot more. Maybe not as much as Sophia Loren, one of Eisie's favorite subjects, who has loved the camera her whole life (and the camera has returned the affection), but still, a whole lot more. And once your subject starts liking the camera, the camera likes them right back. Result? A good portrait session, as opposed to the photo equivalent of a root canal.

> **How to Get This Type of Shot:** When lighting, especially women of a certain age, and *especially* an iconic, classic beauty like Sophia Loren, think soft. Think of your light as a soft blanket that needs to wrap the face gently, open up the eyes, and eliminate shadows and lines. This was an over and under combination that effectively became just one continuous light source because of the lack of ceiling height (we were shooting in a hotel conference room).

There is a softbox above her face, camera left, and a smaller softbox below her face, but they are squished together so closely they really just become like a big, soft umbrella that embraces her face, allows her to move and express, and gives volume and depth to her hair. Occasionally, when I have the two sources so close to one another, I take a 12' silk (or a bed sheet) and just

"He broke down their defenses. He got up close and personal. They allowed him to touch them, the beginnings of trust."

drop the cloth over the entire lighting rig. Looks like you got a big version of Casper the Friendly Ghost on the set with you, but the whole thing just glows and radiates light at that point. You can still minimally control the direction and impact of the light, because you have two sources underneath the cover, and presumably, they are running out of two separate power packs.

Which brings me to an important point. Though it may get pricey, the best lighting outfit you can sort out for your shooting needs should consist of one power pack per head. So, if you go out with three heads, you should have three power packs. That way, you have independent power and ratio control over each of your sources, and you are not compromised or hamstrung by running two heads out of one pack. It also gives you redundancy if a pack or a head goes down. I've been asked over time to light some really big stuff, so I have 14 power packs and 17 heads.

But, of course, I am in desperate need of professional counseling.

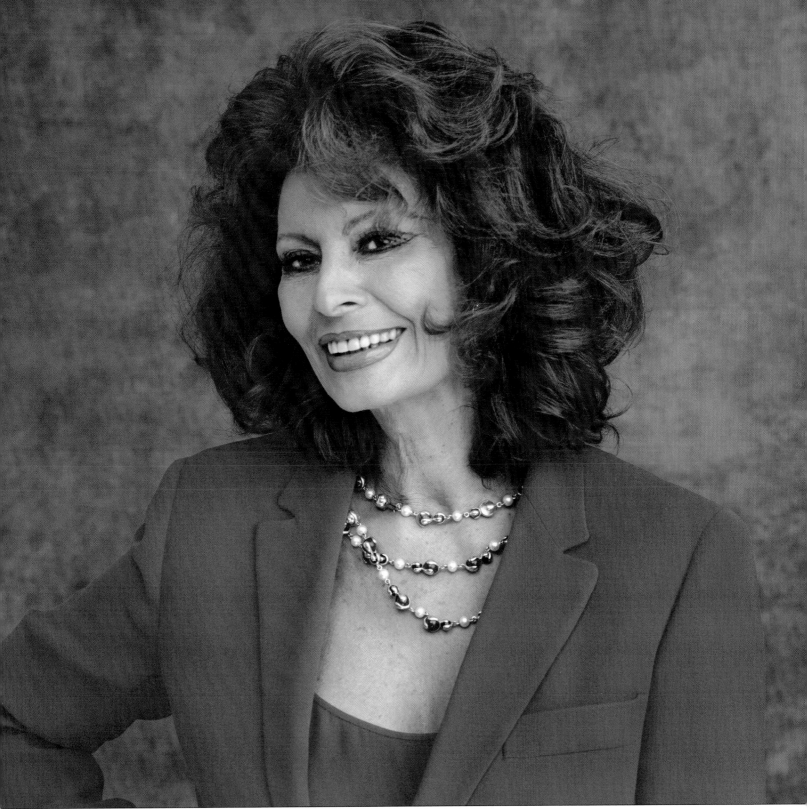

Sophia Loren

"There's nothing as sweet and simple as basic human interaction. It trumps everything."

Sometimes as photographers we almost insist on things being too complicated. We beat ourselves up because we think the simple solution isn't good enough and the perfect photo is always out of our reach. When you're in a tight spot (that would be most of the time), remember there's nothing as sweet and simple as basic human interaction. It trumps everything.

Here's an example: I was assigned by *Life* to do a story on alternative medicine. One of the stars of that show at the time was Mehmet Oz, a doctor from New York-Presbyterian/ Columbia Hospital who employed alternative and New Age medical techniques.

The famous Dr. Oz gave Yankees Manager Joe Torre's brother, Frank, a heart transplant and got

even more famous. My job was to get a picture of these three guys at Yankee Stadium. I was on the ball field at high noon. Far from ideal.

What do you do in five minutes with three pleasantly lumpy guys who are looking to you to tell 'em to do something interesting?

As friend and mentor, Jay Maisel, always says, "Look for light, color, and gesture." They're the holy trinity of photography. In this situation, I went for gesture. It was all I had. I put Dr. Oz in between Frank and Joe. Then I smiled at them and said, "How 'bout you guys give the doc a big Brooklyn smooch?"

Without hesitation, Frank and Joe planted wet ones on the doc's cheeks and Oz lit up like crazy. I quickly dropped another roll in the camera.

My excuse to get people to do things again has been the standard: "You know, just in case the boys in the lab have a bad day, let's just get a couple of frames on a different roll." Always works. Face it, nobody wants to do this all over again, including me.

Another smooch. The doc beams. We're done.

"That's it? We're done?" asked the *Life* reporter.

I was already packing up. Sometimes it doesn't have to be hard.

How to Get This Type of Shot:
One method I often use to overcome harsh available light is to use a full-power strobe through a really big umbrella. It fills the faces nicely and opens up the shadows in a really even way. That's what I set up here, off camera right.

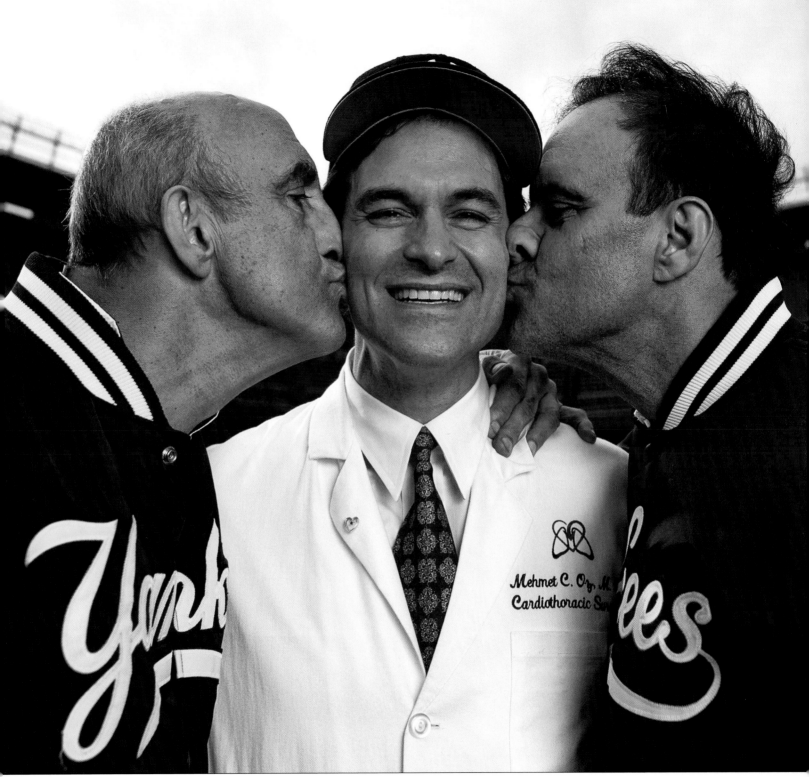

Frank Torre, Mehmet Oz, Joe Torre

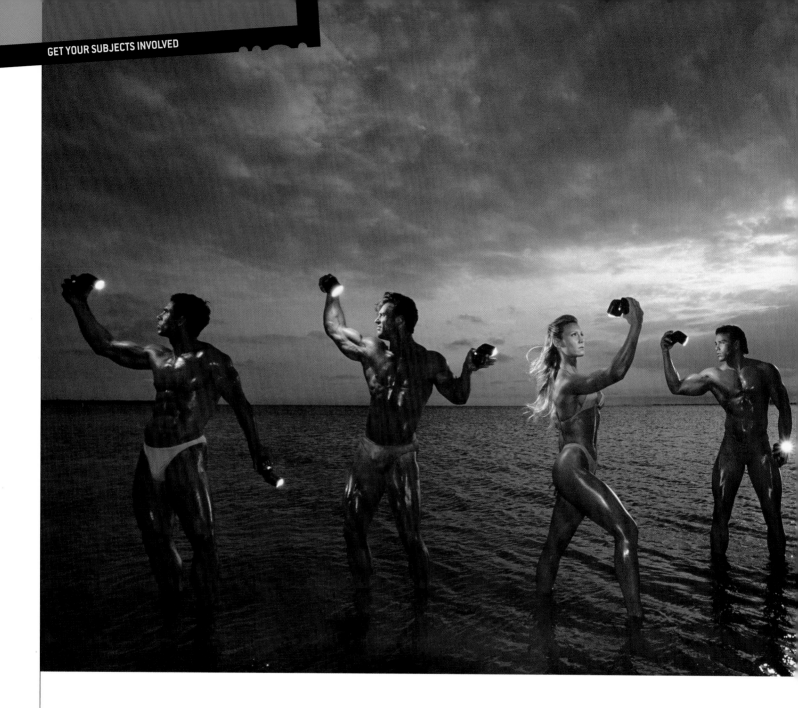

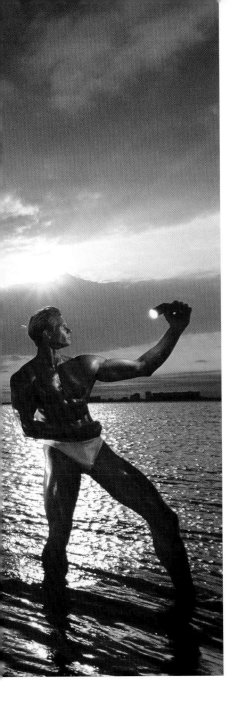

"I gave flashes to these body builders and told them to go light themselves.

Trust Me, they were into it."

Sometimes, especially when I am just plumb out of ideas (a not infrequent condition), I ask my subjects for help. I'll pose them a question: "Is there any way you would like to be photographed that you have never been?"

Sometimes you get no answer. Other times, believe me, you get suggestions that would be unwise to follow up on. And, occasionally, you get a notion, a snippet of an insight that unlocks the door to a successful photo.

That's one way of getting your subjects involved. Another is to make them actors on your stage and have them collaborate, physically, in the success of the picture. Body builders are like statues, monuments to physical perfection. They are like pieces of sculpture that, just like in a museum, need drama and highlights.

So I gave these body builders a mission. Light themselves. It involved them, and intrigued them, and in a way, made them the art directors of the photo. They would strike a pose and then light that pose. It was cool and it gave them something to concentrate on other than the cold ocean water I was asking them to stand in.

These little flashes are great. You can zoom them and control their spread and intensity. The generation of flashes we have now can be controlled wirelessly from the camera. You can push the output up or down, and never leave the tripod. That's a significant advantage when the sun is sinking, the waves are sloshing, and your subjects are freezing.

You have to be able to turn on a dime.

I suggested a story to *Life* on strong women and singer-songwriter Fiona Apple fit the bill. Perfect, since she was riding her *Tidal* wave of success.

Fiona had always been shot as a waif—tendrils of hair blowing (dressed in lingerie), out in some sort of lily field. She told me she wanted to chuck that scene and be a warrior woman in a suit of armor. I was like, "Cool, babe, works for me!"

We did the whole Camelot thing in a daylight studio. A big deal with hair, makeup, styling, painted back-drop, falling rose petals, fake blood on the sword, catering, crew, managers, hangers-on. Everything. All the while, her manager is heating up about how late it's getting. I was like, "You brought her late, okay?"

Finally, he explodes and says, "Gotta go now and the subway is the only way." (It was rush hour in New York and she had a gig in Jersey.) I looked at Fiona over the camera, "Get on the subway in the armor?"

I shout for a camera, wide lens, hot shoe flash, green and magenta gels, and a bunch of 100-speed 35 chrome. We bolt and slip her through the turn-stiles—sword and all—unnoticed. Subway came right away and I started ripping film[1] like crazy for five stops. On the train, New Yorkers, true to form, avoided eye contact.

The studio shot went away and the subway shot (flash-on-camera, $1/15$ of a second at f/4, a hand-held mess of a photograph) ran as the lead.

You never know.

How to Get This Type of Shot: On the subway, to match the fluorescent lights, I put a green gel on the strobe, and a 30 magenta filter on the lens to clean up the fluorescence and give me good skin tones. The key to the picture was making this hot shoe flash look like good light. I did that by using a Lumiquest 80/20, which lets 80% of the light go to the ceiling and 20% go towards your subject's eyes. Shot with a 20–35mm zoom lens.

> "We bolt and slip her through the turnstiles-sword and all-unnoticed. Subway came right away and I started ripping film like crazy for five stops. On the train, New Yorkers, true to form, avoided eye contact."

[1] Ripping Film: Shooting bursts of photos—you just keeping shooting without ever lifting your finger off the shutter.

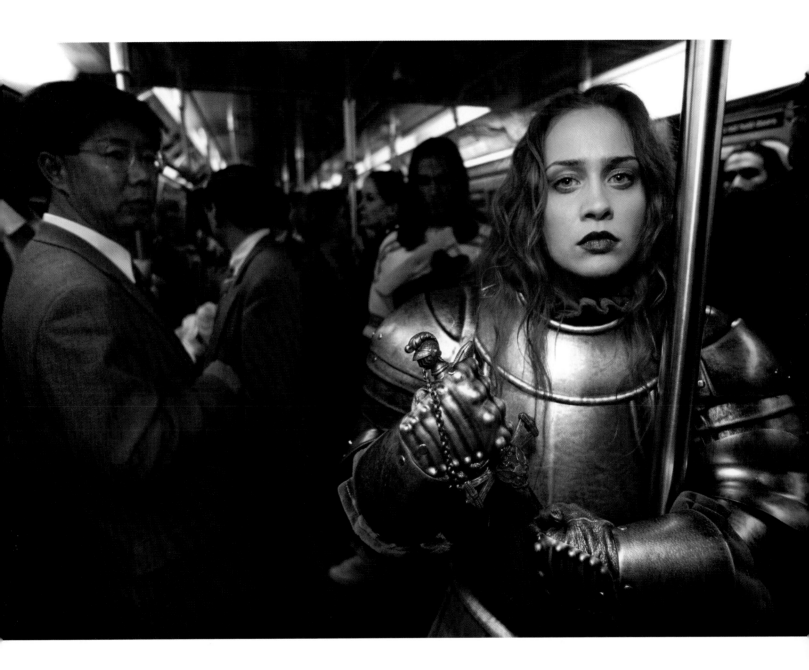

Fiona Apple

No matter how much crap you gotta plow through to stay alive as a photographer, no matter how many bad assignments, bad days, bad clients, snotty subjects, obnoxious handlers, wigged-out art directors, technical disasters, failures of the mind, body, and will, all the shouldas, couldas, and wouldas that befuddle our brains and creep into our dreams, always remember to make room to shoot what you love. It's the only way to keep your heart beating as a photographer.

This kid is 15 years old, and I literally thought an angel had walked into the room. She shook my hand, she was completely comfortable, and from the moment she stepped on the seamless, she owned the camera. The sweet simplicity of the photograph belies the complexity and hard work just below the surface.

"The only way to keep your heart beating as a photographer is to shoot what you love."

Believe it or not, she's standing on white seamless paper. I always advocate independent control of the light on the foreground and background, and in this case, because of the environment, I lost control of the background. The enemy here was the big white box of a ballet studio I was shooting in. White walls, a white ceiling, so the light from the strobes bounced everywhere and onto the white background, which was not what the art director wanted. How do you tame the background?

How to Get This Type of Shot: In a case like this, the control of the light on the background is as important as the control of the light on the foreground. We cut the foreground light so it did not spill as much with a 12x12' solid (a large piece of black cloth positioned just out of frame to the camera's left). This is called a "flag" (in this case, a big flag) and what it does is soak up the light. I used an Octabank[1] and a floor skip, which is a strobe bounced off the floor (usually off a Lastolite panel[2]), positioned directly under the main strobe to the right of the camera. I shot this with a 70–200mm lens. The blue striations of light came from one strobe (no softbox, no umbrella, no nothin') with a blue gel over it, placed low, and I positioned a number of the workout bars in the dance studio in front of the lights to give the background some variation.

[1] Octabank: A large softbox, slightly over 6' wide. A source of very soft, reflected light. An industry standard for both studio and location portraiture.

[2] Lastolite Panel: A kit that has both diffusion and reflective material that fits onto a rigid, collapsible frame. Comes in 3x3', 3x6', and 6x6' sizes. Ideal for diffusing or flagging light sources, or simulating window light. Breaks down into a small, light duffel bag. Very roadworthy.

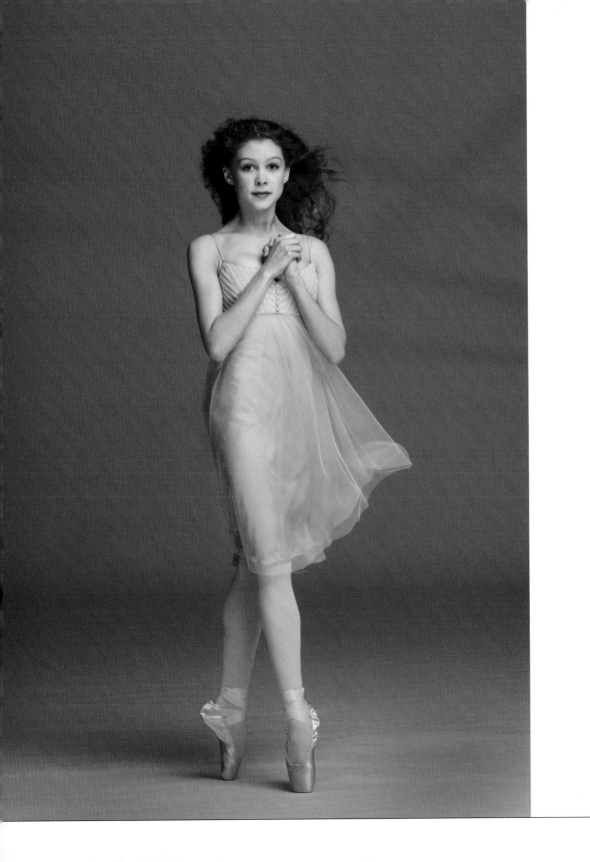

Chapter Two
Keep Your Eye in the Camera

Chapter Two

KEEP YOUR EYE IN THE CAMERA

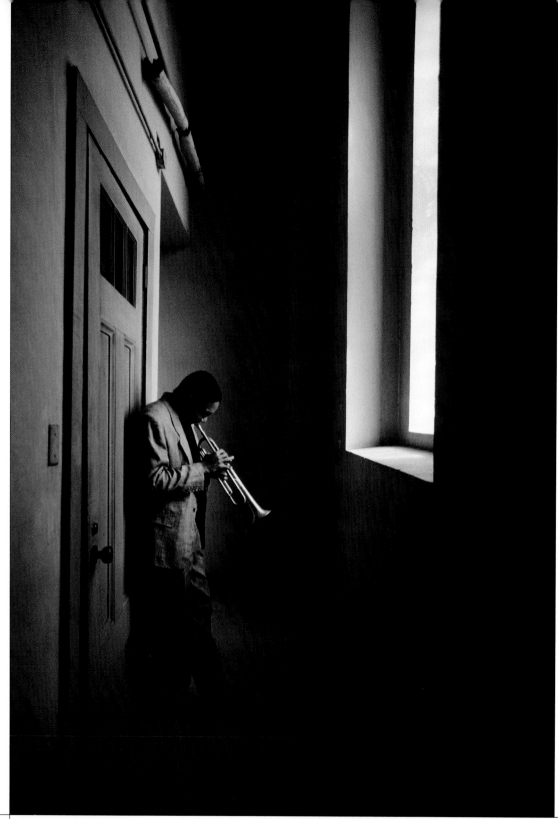

Wynton Marsalis

Respect, and the lack thereof, is always a hot topic on the photog threads. Apparently, we think of ourselves as a bunch of Rodney Dangerfields with motor drives.

Well, who's to blame for that one? Can you really expect red carpet treatment showing up in cutoffs, four-day stubble, and a t-shirt that poses the question, "Did You Get Yours Today?"

I got sent to New Orleans to shoot a pre-Super Bowl story for *Sports Illustrated*. Great job, and it just happened to coincide with the death of the former Mayor, Dutch Morial. There's nothing like dyin' in New Orleans. They have a party for you.

So I hit the street to shoot the jazz procession heading for St. Louis Cathedral. I was in dress pants, suit jacket, white shirt, and a killer tie. I was lookin' good, if I do say so myself. (Despite the festive nature of the funeral, it was still a funeral.)

I made my way to the balcony in the church, to make general views. There was a dignified gentleman next to me holding a trumpet. He turned and looked at me. "Man, that's a bad tie," he said. "I'd like to take your picture," I replied.

And the great jazz trumpeter Wynton Marsalis came over to the window for a quick portrait.

A professor I had in college used to tell me that if someone won't listen to what you have to say because you're not wearing a tie, then put on a tie, 'cause what you have to say is more important than not wearing a tie. He was right.

"A professor I had in college used to tell me that if someone won't listen to what you have to say because you're not wearing a tie, then put on a tie, 'cause what you have to say is more important than not wearing a tie."

*"Your light could become unpredictable.
That's a good thing. Predictable is not
where your lighting wants to be."*

We go through doorways all the time. So does light. So put a light out there, in the hallway. Fly it through the door. See what happens. You just might be done.

The doorway actually frames the light, and gives it shape and edge. Might even give it some color, depending on the paint job in the hallway. If there is variation to the paint, or a shine to it, or the door itself is reflective, or has a pane of glass, your light, when bouncing around through all this stuff, could become…unpredictable. That's a good thing. Predictable is not where your lighting wants to be.

And, if you by chance have a 3x6' Lastolite panel,[1] one of those puppies just about fills a doorway. Instant softbox!

No Lastolite panel? A bed sheet and some gaffer tape will do.

This shot has no diffusion. I put a battery-operated strobe head outside the locker room, which had kind of a wide door opening that led out to the practice field. The light is hitting a couple of things, like a bank of lockers, which is causing the shadow behind the player's head—a happy accident (I love those!)—that produces the sharp line between that shadow and the highlight on the wall. (This is the opposite of the highlight/shadow play on Bobby's face, which is another happy accident I thought about later, but if I told you I was going for that or was even aware of it on location, I would be lying.) The rest of the light flies around the yellow walls of the locker room and, guess what? It gets warm! Light picks up the color of what it hits.

Unpredictability. Accidents. Not good when you're engaging in, say, brain surgery, but when lighting…wonderful!

[1] Lastolite Panel: A kit that has both diffusion and reflective material that fits onto a rigid, collapsible frame. Comes in 3x3', 3x6', and 6x6' sizes. Ideal for diffusing or flagging light sources, or simulating window light. Breaks down into a small, light duffel bag. Very roadworthy.

"Try it, you might like it. You never know."

Winona Ryder had a loft bed and high ceilings in her NYC apartment. The actual bedroom area was super-tight, up a small staircase, big enough for the bed, her, and me. The ceiling was out of bounds for a bounce—too high.

So, where ya gonna put the light? There was a room directly beneath the loft, and a small channel, sort of in the shape of a strip light,[1] where light from that room could filter upwards to the bed chamber.

How to Get This Type of Shot: So I put a light downstairs and fired it into the wall by this little opening. Never tried a bounce light from the floor below my subject, but you never know. Turns out light skittered up through the opening, hit the wall by the bed, and presto, we were lit.

It wasn't a tour de force of lighting, but it was good enough. When you've got Winona Ryder in her pajamas, in her bed, how much further do you need to go?

When I'm figuring out where to put the light in a situation like this, in my head I'm channeling my grandmother trying to get me to eat Brussels sprouts or something. You know, "Try it, you might like it. You never know."

[1] Strip Light: A strip light is simply a long, skinny softbox. It's great for adding an edge light around the body of an athlete.

Winona Ryder

No matter how many megapixels you've got inside that fancy machine you hold in your hands (and the megapixel wars are overrated), they aren't worth beans if you don't hold your camera steady. This needs to be worked at and practiced.

I'm right-handed, but left-eyed. Go figure. After years of straining to focus through lenses, my left eye is so much stronger than the right, I'm amazed I just don't walk around in a circle all day long. But, being left-eyed is an advantage when holding your camera at slow shutter speeds. Years ago, Keith Torrie, a terrific *Daily News* shooter with a similar eye/hand change-up, pulled me aside and showed me how he held a motor-driven camera. Keith was known around the shop as one of the few guys who always made a good neg. That meant he knew what he was doing.

He showed me how he threw his left shoulder forward and stuffed the base of the motor drive where his chest and shoulder met. There are no lungs up there, no heartbeat, just muscle and bone. Work it properly and you might as well have a third leg.

Nowadays, too, you don't have to worry about changing f-stops and focusing constantly with your left hand. So take that flipper and slap it over the outside of your main support—your right hand. Elbows into your gut, exhale, and you can shoot hand-held at speeds you never thought were possible.

How to Get This Type of Shot: This is just a straight available light photo taken from a helicopter, but the key to getting a shot like this is to be able to hold the camera steady while using slow shutter speeds like $\frac{1}{30}$ to $\frac{1}{10}$ of a second. This was taken with a 17–55mm Nikon lens, at $\frac{1}{20}$ of a second, at f/2.8.

"No matter how many megapixels you've got inside that fancy machine you hold in your hands, they aren't worth beans if you don't hold your camera steady."

"This is business as usual on
the Lower East Side of New York."

Poppo and the GoGo Boys were a big deal in the performance art scene down in the alphabet streets of Manhattan. He had amazing control, turning his Day-Glo body into all sorts of twisted sculpture.

Problem was, a neighbor called it into the local precinct as a jumper in progress, and two very adrenalized NYC cops burst onto the roof. They were wired and they were pissed, having just sprinted up a six-story walkup.

They ordered me off my ladder and started barking questions. How do you explain this away and not sound like you need a shrink or some jail time? I'm trying to calm the situation down, all the while eyeballing the rising sun and watching my picture disappear.

They were having none of it until I produced my permit. Like most cities, there's a permit office in NYC for TV and still shoots. I was covered. So, though I was still nuts as far as they were concerned, I was legally nuts. They left, and I got my shot.

How to Get This Type of Shot: Shot with one strobe. (If I hadn't used a strobe and had tried to use just the available light at sunrise, I'd have had to expose for the subject, so the background would have been totally washed out.) The key to doing this is to match the color of the light and the angle of the strobe to the rising sun (I added a gel to the strobe—a half-cut of CTO[1]). Basically, you take the light stand and put it up high, right in the path of the rising sun, so the strobe hits the subject at the same angle the sun would hit the subject. That way, you can mimic the feel of sunlight but it gives you control over the exposure of the scene. There's no umbrella, no softbox—just the raw light, just the way the sun would be.

[1] CTO: Color Temperature Orange. It's an amber gel, available in various intensities, that pushes daylight towards the warm (tungsten) end of the color scale. A half-cut means you get half the warmth of the full gel.

The Over-Under. No, this is not something you transact with your bookie. This is a lighting combo that gives you the classic "glamour look."

How to Get This Type of Shot:

Use two softboxes. Position them high and low. Think of an open clamshell with your subject's face at the open edge, and your camera peering at him or her from the other side. The upper source is middling size…say 3x4'. The lower light is smaller, maybe 1x2'. The higher source is dominant in terms of size and exposure. It runs maybe a stop to a stop-and-a-half over the output of the lower box, or fill.

Move your subject into the wide end of the clamshell, as tight as they can get. Fill the frame. Photographer adds a dash of appropriately encouraging/suave/smarmy/inane patter from camera, and *voilà*! Dat's one fine lookin' photo subject you got there!

Generally, this is a light grid for the ladies, who, if you do this right, will love you forever.

"This is a lighting combo that gives you the classic 'glamour look.'"

You've gotta taste the light, like my friend and fellow shooter Chip Maury says. And when you see light like this, trust me, it's like a strawberry sundae with sprinkles.

The Vikes have this amazing window at one end of their practice facility that turns the whole place into a north-light studio.[1] I saw this and was foaming at the mouth. I was afraid the light would go away and I'd lose it.

> *"Like my friend and fellow shooter Chip Maury says, you've gotta taste the light."*

I told Culpepper to "go out there with a football and stare at the goalposts like a little kid. Like ya never scored a touchdown before in your life." I think he did it 'cause he was scared. I was so crazed about the light that maybe he thought I'd hurt him before the season started if he didn't cooperate.

He was already leery of me. When I walked in to meet him, he looked at me and said, "Whoa, you're that guy from *Fargo*!"

And I always thought I was better looking than William H. Macy.

> **How to Get This Type of Shot:** This was shot with nothing but straight-up natural light—the trick was getting the rest of the indoor practice facility blacked out—I had to race around to find the facilities manager and convince him to turn out all the lights. It was shot on a tripod using a 50mm lens on a Mamiya 6x7 camera, medium format.

[1] North-Light Studio: A studio with rich, sumptuous, soft natural light that generally comes from a north-facing window. You want good portrait light? Head north.

Daunte Culpepper

"Sometimes, when you've got a camera in your hands, you can convince yourself you're Spider-Man."

Sometimes, when you've got a camera in your hands, you can convince yourself you're Spider-Man. I mean, Peter Parker's a newspaper shooter, right? Quick change of uniform and he's out there slinging webs and diving off buildings.

Or climbing rocks.

I was shooting a University of Alabama home football game at Bryant-Denny Stadium, which is like going to church with your cameras. I mean, these folks take football seriously.

The band and the cheerleaders were all lined up on the library steps doing a lively number, and I thought it would be cool to shoot them with a long lens from a higher vantage point. There's a ceremonial rock out in front of the library, some sacred stone that actually looks sort of like they swiped it from Stonehenge. It's about, oh, eight or nine feet high.

Perfect, I thought. I'll climb the rock and get my long lens view! An elderly couple was standing nearby, and I asked them to hold my cameras for me, and my shooting vest. They were sort of puzzled as to why a complete stranger would hand them three very expensive, motor-driven cameras and an article of clothing, but they were willing to go along. They looked trustworthy and not capable of running very fast.

I took a few steps back and started sprinting. Wham! I went from Spider-Man to Wile E. Coyote in a heartbeat. I mean, I just pancaked myself into the side of this rock. And not content with making a fool of myself just once, I tried it a second time.

Same result. Even worse, 'cause the very public humiliation of the first go caused me to run at it harder. I sort of slid down the face of the rock, just like in the cartoons.

I looked over at the couple, who were staring at me with their heads tilted, like a pair of puzzled cats. I got to my feet, retrieved my gear, thanked them, and staggered off. Simple fill flash in the locker room was looking awfully good.

I'm sure those folks told everybody they saw that day about how "that photographer fella" did the damnedest thing…just ran into the rock—twice!

How to Get This Type of Shot:

In a shot like this, forget about front-to-back true color. I mean, you can get close, but precise color control? Fugheddaboudit. You walk into a locker room like this, and you don't know if the fluorescence is warm white or cool white, or when they changed the bulbs last, or if they're GE or Sylvania. Then there's that tiny window off to the left, and then how about the tungsten bulbs in the makeup mirrors? Plus, you've got blond hair (lots of it), bunches of different skin tones, red shirts, and white boots.

Do you have time in a fluid situation like this to sort it out and walk around with a color meter and do some testing? That would be a no. You have to think and move fast. The action is frenetic, the pace is fast, plus every minute you're in there means your lenses are getting a thicker coat of hair spray.

Whaddaya do? Go for skin tone and let everything else go to hell in a handbasket. It's really all you can do. When I shot this, I went with the tried and true film solution of a full green conversion on the strobe, and 30 points of magenta on the lens. Now, I would highly recommend doing a preset white balance. To do this, find a white wall or carry a collapsible gray card (18% gray on one side, white on the other, collapses to a small circle and fits easily into your camera bag). Fill the frame with the white wall or the card. Shoot with either available light or flash. The camera will register the preset, and give you a good white balance for that particular mess of a room you are in.

Surprise me.

That's the best advice I ever got from a picture editor.

"This was guerrilla filmmaking. We got the lights ready, set the fire, and shot like mad."

The art scene on the Lower East Side of New York in the mid '80s was, uh, surprising. Yeah, that's the word. The subject here was David Wojnarowicz, now deceased, a painter, filmmaker, and activist. He was making kind of tribal art at the time, so I made an urban version of the village campfire out of a Department of Sanitation trash can. (Had to swipe it off the streets of the city and throw it in the back of my van. It was like a kidnapping. Pulled up, looked around, and threw it in. The van smelled awful for days.)

This was guerrilla filmmaking. We had a permit, but no police protection in what was then a very dicey neighborhood, nor did we have FDNY approval to set a fire. We got the lights ready, set the fire, and shot like mad.

He can't be lit with just the fire. Too iffy, and he woulda been all sorts of unsharp. So we nestled two battery-operated strobes into the base of the fire, aimed up at him and lighting the whole scene. I also put a couple of ungelled strobes behind the rocks on either side of him. They do two things: separate him from the background, and give me an extra measure of sharpness.

I was lucky I did this, 'cause the fire got big quick, and burned through one of the strobe cables near the blaze. Bye, bye light! Wasn't aware of it at the time, of course. But without those wing lights, we would have had very little strobe punch, and thus very little sharpness in our screaming subject.

When dealing with an exposure situation like this, you have two things you have little to no control over: the deepening sky, and the very erratic fire. The strobes give you a bit of leverage, and it pays to keep the subject just on the edge of the firelight, in semi-darkness, where your strobes can take over and freeze him, while your shutter speed takes care of how much or how little fire you've got raging in your picture.

David was a character, to be sure. He wanted a fake Uzi machine gun, and his blue painted face was entirely his idea. I was fine with that, the odder the better in my book. We were chatting after the shoot and he asked me who I was going to shoot next. (All the artists down there knew each other, and knew *Life* was doing a story.)

I replied that I was shooting a portrait of an artist who had undergone sex change surgery and whose art tended to relate to that specific experience. He nodded knowingly, holding the phony weapon, his face glowing blue. "You'll have a good time photographing her. She's really weird!"

In New York, weird is relative.

David Wojnarowicz

"Using the flash freezes him, but allows me to use a slower shutter speed, which blurs the world outside the car. This sends a message: fast-moving, powerful man on the go."

I spent a week with corporate big shot Larry Tisch as he was preparing to buy CBS. I needed a lead, something jazzy to kick off the story.

I put the flash in an unusual place—outside the limo, aimed at the backseat side window (it was attached using a Bogen Magic Arm, which let me clamp the flash to the limo, right by the driver's rear view mirror).

This wasn't frivolous. I had good editorial reasons. First, it gave me the main light off-camera (and as I mentioned before, direct flash is a disaster) and it also gave me control over the look of the picture colorwise, because the flash was gelled to make it slightly warm.

Using the flash freezes him, but allows me to use a slower shutter speed, which blurs the world outside the car. This sends a message: fast-moving, powerful man on the go. Also, he was in the backseat of the limo. Another bunch of messages: power, money, and very importantly, the photographer is right there with him, behind the scenes, inside the fence. It says to the reader: Stay with the story, you haven't seen this before.

Sheesh, you mean I can do all that with one lousy flash?

You can, until the driver forgets the light is boomed two feet outside his window and squeezes left onto 5th Avenue, splattering it against the rear view mirror of a double-parked van.

I only had one flash with me, so I turned to Tisch and said, "You know, I think we got it!"

Larry Tisch

30 magenta plus full green equals good sunset.

Uh, wanna run that by me again? In English?

One of the tough things about digital is the Fluorescent white balance setting. I use it, monkey with it, push it up and down a bit, and can still get results that look like I'm shooting through an aquarium that hasn't been cleaned in a while.

So I often do things the old-fashioned way. I set the white balance to daylight, pop a 30 magenta filter on the lens and a full cut of green conversion filter on the flash, and boom, we're cleaned up with good skin tones to boot. (The green flash filters are fluorescent conversion filters that come in different strengths.)

You've got your skin tones nice and normal, your disgusting green fluorescent foreground wrestled to the ground, and...Ta Da!...your not-so-great sunset has just exploded into an extravaganza of pinks and violets and reds, the likes of which will make your readers swoon and start thinking Tahiti, even when they're looking at Piscataway.

How to Get This Type of Shot: The only consistent thing about the NYC subway system is the fact that when the cars pull into the station, they always stop at the same spot. That simple regularity made this shot possible in real time, without setups, models, and a staged train. I scouted a good area, sat Bruce on the basketball, and set up a 1x2' softbox on a floor stand on camera left to mimic the door light of the train. Gelled it full green and put 30 points of magenta over the lens. The sky was crashing into twilight and I'm nervously looking over my shoulder, waitin' on a train.

One came in, blessedly. The doors opened, I shot three frames of Kodachrome, and the doors closed. By the time the next train rolled in, the sky was gone, and so was my shot.

P.S. Just try this nowadays with a tripod, camera, and flash on the subway. Hello, officer!

"City lights go green. 30 points of magenta cleans that up. And your sunset doesn't hate it either."

FILTER!

"You can miss lots of moments with your head stuck in your LCD. Checking what just went on is a surefire ticket to missing what's about to go on."

I became a world-class chimper from the very first moment I held a digital camera. Click, click, click. Ooh, ooh, ooh! Click, click, click. Ooh, ooh, ooh! That damn little LCD monitor's like crack cocaine. Better than a Polaroid and I didn't have to wait 90 seconds in the cold weather with the thing tucked under my armpit, hoping it would develop properly.

Man, it's cool. But also dangerous. You can miss lots of moments with your head stuck in your LCD. Checking what just went on is a surefire ticket to missing what's about to go on.

None of these pictures is huge just on its own. It is the sequence that works, the moment-to-moment agony and apprehension of having your test paper corrected. The sum is definitely greater than the parts and if you are checking the LCD, you are not putting together the parts.

Be disciplined. Keep your eye in the camera and your head in the game. Plenty of time later to moan, cheer, laugh, or cry.

*"When I look at a window, I will
often say, you know, 'nice view.'
But in my head I'm saying, 'light source.'"*

Window washer Jan Demczur saved five people trapped with him in an elevator on 9/11 by using his squeegee blade to scrape through 6" of sheetrock. That squeegee now resides in the Smithsonian.

I photographed Jan on the world's only giant Polaroid camera[1] immediately after the World Trade Center attack. We got to know each other a bit. He's a likable, simple guy. Like many, his life went on hold after 9/11.

About a year later, I caught up to him at his home in New Jersey. At that time, he didn't go out much. There was a sense of isolation—9/11 lingered.

When I look at a window, I will often say, you know, "nice view." But in my head I'm saying, "light source."

Where does most light come from anyway? The windows! Ever wonder why the cameras are moving and the actors are dialoguing and you're seeing all over a room in a Hollywood movie but you never see the stands and the lights? They're all outside, sometimes down the block.

Jan's window was huge and on the first floor. Light source! I put a strobe on the front lawn, triggered with a pocket wizard.[2] The lacy curtains were perfect as an imperfect, irregular softbox. One pop and the room filled with light. He sat on the bed, alone with his thoughts.

> **How to Get This Type of Shot:** When you do this, use one strobe head. If you put up two lights, you might have double shadows, which is something the sun does not do, it being a singular light source. If you have to use two heads and two packs for power reasons, make sure the second head is clamped to the same stand as the first and line it up exactly.

[1] Giant Polaroid Camera: Referred to as "Moby C," it is the world's largest Polaroid camera, capable of making life-size images 40" wide by 80" tall. The interior chamber of the camera is the size of a one-car garage, and it was devised by Dr. Land and the engineers at Polaroid.

[2] Pocket Wizard: A highly sophisticated radio-triggering device used for firing strobes and remote cameras. Think of it as a really fancy garage door opener. (Just kidding. These are seriously effective field units.)

Jan Demczur

Make your day longer. Now that doesn't sound desirable. But it is if you're a photographer desperate for as much golden hour as you can get. One way to do that is to use water.

Ever notice how the streets in the movies are always wet? Did it always just rain?

Nope. But the water truck just went through. Streets glisten when they're wet. They look cooler. You pick up f-stoppage.

When doing flash at the edge of sunset, you're desperate to get that beautiful sky and face of your subject. Not too tough, actually. Hit him with some light, crank your strobe up at +2, underexpose the sky. No biggie.

But then, where is your subject standing? In a black hole, most likely. The green grass looks like the dark side of the moon and your environment is, well, gone. (Holy mudhead, Mackerel, more Science High! It's…gone!)

Okay, okay, most people reading this book won't remember *Firesign Theatre*. And of course, if you were a *Firesign* fan, you're lucky to remember anything. 'Nuff said.

But I digress.

You can extend your sunset working life dramatically by putting your subject next to a body of water. The water remains almost the value of the sky exposure and stays right with you till the sky is almost gone.

Some people think photographers get direction from some mystical, Oz-like, all-knowing editor: "Use the force, Luke." Given such divine direction, brilliant, jaw-dropping photos effortlessly proceed.

It's a bunch of bullpucky.

"As a photographer, it's better to ask for forgiveness than for permission."

Got a call in the middle of the afternoon, New York time, to go to Los Angeles and shoot World Series hero Orel Hershiser—the next day. I flew that night. I wasn't gonna turn down an assignment like that. "What kind of picture are you lookin' for?" I ask.

Exact quote, I swear: "Well, I just thought you'd have him in a studio on a pile of dirt with some light coming down on him. You know, because he's a pitcher."

Hmmmm….

Hershiser got the nickname "Bulldog" from Tommy Lasorda. It was all I had going in terms of an idea. I called an animal talent agency and rented the bulldog from the *Jake and the Fatman* series. He was so ugly, he was cute. His trainer brought him to Dodger Stadium. Orel loved it. I put them on the pitcher's mound, faces close together. We smeared bacon grease on Hershiser's cheek—the dog went nuts, and the hero of the World Series had a ball.

Sometimes you receive inspiration and direction, divine or editorial. Most of the time, baby, you're on your own.

When you rent from an animal agency, it gets very pricey, very quick. A dog, like this bulldog, goes for around $1,000 (in L.A. anyway, where this was taken). The average range is about $500 to as much as $8,000. I know the $8,000 is right because as of the writing of this book, I'm renting an elephant. Her rate (in New York) was $8,000, and the kicker was, I couldn't use her because she was already booked. I kid you not (I wish I could get $8,000 a day). Because she wasn't available, I found an elephant in L.A. (named Suzie) that was *only* $6,000 a day, plus overtime. I kid you not.

How to Get This Type of Shot: The shot here was taken on the pitcher's mound at Dodger Stadium at around 3:00 p.m. To get the solid blue sky behind him, I underexposed the sky by two stops, and lit Orel and the dog with a strobe and an Octabank softbox to the left of my camera.

Orel Hershiser

While I was in the planning stages to shoot Michelle Pfeiffer with the National Gem Collection, I pretty much had the run of the Smithsonian. I got into a lot of back hallways and storage areas, looking for pieces of pictures.

I saw these life masks in a hallway, forgotten, gathering dust. Loved 'em immediately. The people at the Smith rolled their eyes, but were gracious.

It didn't stop there. I needed them moved and my instructions were explicit. Handle them from the base. *Don't dust them!*

"Michelle's living, breathing Hollywood glamour. The diamond's a still life. Both are beautiful and both need to be lit differently, just all at once."

They looked at me like I was nuts. But the dust gave them character and patina, and the feel of an artifact. They were ancient and crypt-like, and made a good frame for Michelle's flawless skin. Okay, so I saw *Raiders of the Lost Ark* way too many times.

Diamonds are cut on a bias for reflectance and brilliance. They need hard light to shine. Michelle made it clear there was to be no hard light near her face. She was real straight about it.

How to Get This Type of Shot:
So I lit her with a straight-up beauty light combo. The gem? Got a strobe projector, one of those puppies that can throw a 3,000-watt-second piece of light the size of a dime across the room.

Cut masks in the shape of every gem to be shot and dropped them over the projector. An assistant stood with the unit and followed the massive stone on Michelle's chest. There's so much extra light pumping into just the gem that it is ricocheting back off the statues, resulting in the little splotch of light just to the right of Michelle's face.

Michelle's living, breathing Hollywood glamour. The diamond's a still life. Both are beautiful and both need to be lit differently, just all at once.

Michelle Pfeiffer

"I don't like mimes, but they kind of give you a free pass. You don't have to explain how strange a picture is, 'cause, well, you've got a mime in there."

I don't like mimes, but I've used them in shoots on numerous occasions just because they're so damn odd. It gives you a free pass. You don't have to explain how strange a picture is, 'cause, well, you've got a mime in there.

When I shot this, in the muck of the Prospect Park Lake in Brooklyn, my assistant was a 6'3" cowboy out of Colorado named Garth. He was bewildered by the painted, wordless men. Maybe they don't have mimes in Colorado.

He came up to me at the camera and whispered, "Hey Joe, if I beat the $#!& out of one of these mimes, do you think he'd say something?"

FYI, this was an illustration for the versatility of the Nikon SB-26, which had an internal slave eye.[1] There's a strobe in the umbrella, one in the boat, and one to camera left, lighting the hooked mime.

I'm not sure, but I think I've always wanted to say, "hooked mime."

How to Get This Type of Shot: The shot was taken at dusk—the sky is really intensely blue, I shot tungsten film, and the strobes had the CTO gels I talk about on page 82. So, the tungsten film made the scene cool blue and the gels made the light from the flashes warm. If I reshot this today using digital, I would set the camera's white balance to Tungsten, but still gel the strobes to make them warm. Here's why you need the gels: the Tungsten white balance makes the fading daylight go blue, and the strobe is a daylight source too, hence it will go blue if left ungelled. You don't want blue on blue on blue, so time for the gels. One full conversion brings the daylight flash to a tungsten balance, so it would look neutral or white. But you want the flash to be warm, not neutral. So put one more CTO on there, making it a double-gel. Now you've got the cool, cool blue sky and warm subjects. It's a good combo. Always remember that warm and cool colors vibrate next to each other. They engage the eye. They work well together.

Note: You can now fine tune a camera like the D3 to get the coolest effect possible. That, along with some underexposure on the order of –2 EV, will give you an intense, cobalt blue when shooting in a daylight environment, especially pre-dawn, or twilight. Not to play on words, but it is, you know, cool!

By the way, do you know how I attach the gels to my Nikon SB-800 flashes? Nothing fancy—Scotch tape. For a while I tried to put little Velcro strips on all my gels, but that was just too geeky—even for me.

[1] Internal Slave Eye: A photo eye or trigger built in to a flash unit, sensitive to sudden increases in light, which will trigger the flash.

This doesn't have to be rocket science.

I was shooting a story on prayer and working with a lovely family who had great-looking kids. One of the young daughters had the face of an angel.

So I'm struggling…wait a minute. She's got the face of angel. I'm doing a story on prayer. Whack! That's why I've got a flat forehead.

Threw a bed sheet over a window with hard sunlight pouring in. Turned the room into a studio. Swiped a macramé tablecloth and pinned it to the wall behind her for texture.

"Throw the bed sheet over the window, and watch the room start to glow."

She got prayerful. I got a cover. It took about five minutes.

FYI, I am a bed sheet thief. If I think I need a broad light source, I swipe the bed sheet from the luxurious Motel 6 I might have stayed at that night and stuff it into my gear bag. There's no weight and it takes up no space.

How to Get This Type of Shot: We've all walked into a room with a little hot shoe flash and looked at hot sun pouring through a window, where it's, you know, f/90, and then just out of the light, where it's f/nothing. How you gonna make that work with a tiny on-camera flash?

Throw the bed sheet over the window and watch the room start to glow. The window was off camera right and the shadow side of her face was just a little too dark. To compensate, I bounced a very weak flash off the ceiling of the room, which filled in the shadow side just enough without overpowering or destroying the feel of the existing light.

When it comes to skin tones, warm is generally better than cool. This is a personal preference, you understand, and it stems from the fact that I feel people look better with a little warm glow, as if they're sitting at a nice, candlelit table at the Four Seasons, rather than looking like an extra on *The Sopranos* who's been hanging on a meat hook for a few days.

Of course, it depends on the mission. You can go either way—the important thing is to remember to choose. Don't let the gear choose for you. WARNING! WARNING! Technical talk starts here!

How to Get This Type of Shot: Flash units come from the factory neutrally balanced for daylight. The output is plotted as a bell curve. At the lower end of the curve, it is burning at a warm temperature. At the top of the curve, it is fairly cool in terms of degrees Kelvin. Depending on certain factors, like strobe duration and shutter speed, your exposure will carve out a piece of this bell curve, and more than likely, the cool chunk of it. Hence, your neutral strobe might look a little blue.

There are any number of ways to fix this. Try a Cloudy white balance, which is a slightly warm version of daylight. Or put a CTO on your strobe. A CT who? CTO: Color Temperature Orange. It's an amber gel (available in various intensities) and it pushes daylight towards the tungsten (or warmish) end of the color scale. You can push it a little, which is natural and pleasing, or you can push it a lot and make somebody look like the Great Pumpkin. Be careful.

I love talking this tech stuff. Strobe durations and bell curves! Whew! Gets me hotter 'n Georgia asphalt.

"When it comes to skin tones, warm is generally better than cool. Of course, it depends on the mission. You can go either way - the important thing is to remember to choose. Don't let the gear choose for you."

*"If you want something
to look interesting,
don't light all of it."*

John Loengard, the picture editor at *Life*, always used to tell me, "If you want something to look interesting, don't light all of it." He's right.

Follow your instincts. Here's the deal: the client was *Parade* magazine and they print on a paper grade that, well, let's just say it's not the best, so they always need color or want color. They kept telling me: no beiges, no browns, make sure you have color. My imagination was all about something really moody and reflective about Tony at this point in his life, and lit in a minimal way on black. Now black is generally not the ticket for success when it comes to a cover.

I had Tony for two hours and I ran four sets: a black, a white, a gray, and a somewhat cheesy painted sunset. I figured the black set would be more of a picture for myself than anything else—yet another unpublished favorite.

We played Sinatra all day in the studio and Tony was in a groove, as he always is. He loved the old prop microphone and he turned that wonderful face into the one light, and it was the picture of the day—and the cover, a rare twofer.

How to Get This Type of Shot: In a scene like this, you try to match the light to the mood. Tony's very soulful, so the last thing I'm going to do is blast him with a whole bunch of brassy, hot light. I positioned a big Octabank[1] to my camera's left and slightly behind him, so it starts to wrap around that famous Bennett profile. I asked Tony to look toward the light while cradling the 1950s prop microphone I had gotten him. Again—details. I had gotten the mic the day before from an L.A. prop shop. Imagine this picture if he had nothing to hold.

[1] Octabank: A large softbox, slightly over 6' wide. A source of very soft, reflected light. An industry standard for both studio and location portraiture.

Tony Bennett

Chapter Three:
The Logic of Light

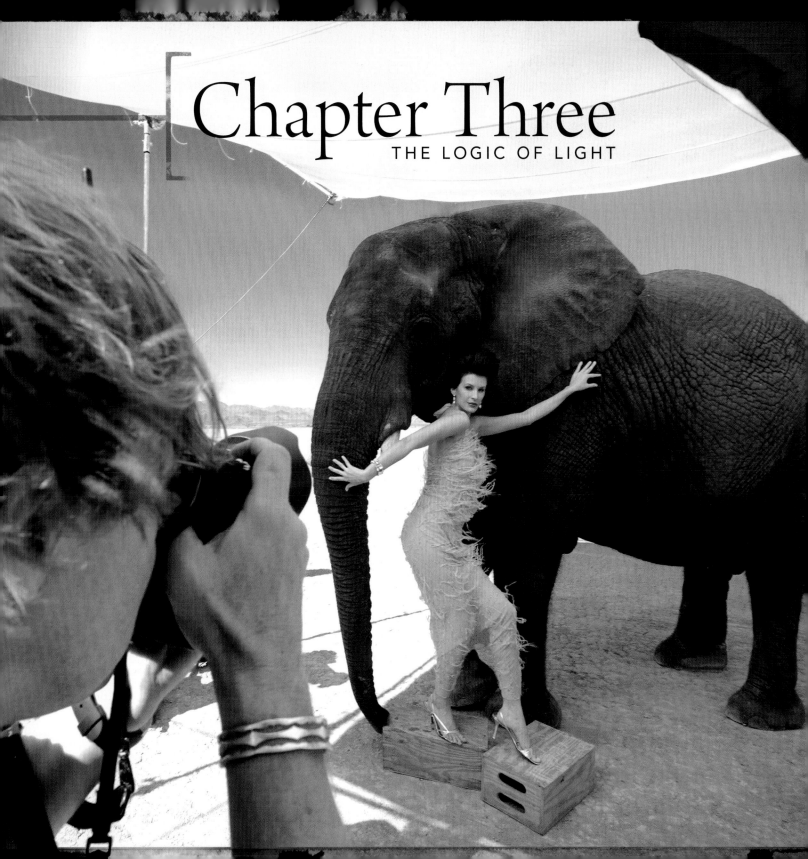

Chapter Three

THE LOGIC OF LIGHT

"Is the only good light available light? Yes.

When I was in school, I wanted to be W. Eugene Smith. He was a legendary staffer at *Life*, a consummate photojournalist, and an architect of the photo essay. He was also kinda crazy.

That was obvious when he came to lecture at Syracuse University and put a glass of milk and a glass of vodka on the lectern. Both were gone at the end of the talk. He was taking questions and I was in the front row, hanging on every word.

"Mr. Smith, is the only good light available light?" came the question.

He leaned into the microphone. "Yes," he baritoned, and paused.

A shudder ran through all of us. That was it! No more flash! God's light or nothing!

But then he leaned back into the mic, "By that, I mean, any &*%%@$ light that's available."

Point taken.

How to Get This Type of Shot: This shot was taken outdoors at dusk in Jaipur, India, during the Festival of Lights using available light. It was taken with a 180mm lens at f/2.8. The soft glow through the veil was provided entirely by the candles.

By that, I mean, any &%%@$ light that's available."*

For the *A Day in the Life of Ireland* book, I wanted to photograph Irish coal miners. I went to Kilkenny, a small village. Met my contact at the local pub (where else?) and asked him about the nearby mine. I was excited to check it out.

He nodded and rubbed his chin. "Yah, yah, we got the mine for sure. Can take ye out there for sure. Thing is, it's been closed for nigh on 20 year." Welcome to "Day in the Life" research!

I did go, and crawled down into a deep, black hole, just to be sure. I turned back, probably just before the sign, "No pictures here."

Okay. What to shoot? I love weddings, so I went and started to check out churches and schedules. The luck of the Irish prevailed and, quite literally, the farmer's daughter was getting married on the day of the book shoot. Met the family. They said yes.

What a wonderful day! Weddings are fun, 'cause people let their hair down and, of course, in Ireland, they *really* let their hair down. Had a ball and made some fun pics.

Almost at the end of the night, the father of the bride came up to me. He was a farmer—barrel-chested, silver hair, forearms like Popeye. He grabbed me by the shoulders. "I don't give a $#!& about the photos," he shouted over the music. "Are ye having a good time?"

When the good times are rolling, you gotta roll with them, and show the frenzy, the fun, and the motion. How do you show things in motion when you are holding a still camera in your hands?

How to Get This Type of Shot: Rear curtain is the way to go. Always remember, no matter what the shutter speed of your camera, the hot shoe flash is firing at a much higher speed. That's why flash freezes a moving subject. So the camera will expose a scene at a shutter speed of say, $1/15$ of a second, but the flash will hit the subject at maybe $1/1500$ of a second, making them sharp. The crucial question is: when does that flash hit them?

In front curtain, the flash goes off at the beginning of the exposure. Not good for motion. In this mode, the flash hits the subject first, and then they continue moving while the shutter stays open, and blur right through their sharp, flashed image.

With rear curtain, the flash goes off at the end of the exposure. That way the camera is exposing, and the subject is moving and blurring, and then BOOM! The flash freezes them, with their blur and activity behind them, not through them. The result is a logical flash-and-blur effect, one that makes sense and has direction, and gets the notion of motion across to the reader.

FYI, I simply leave my cameras set to rear curtain all the time. At $1/250$ of a second, it doesn't matter. But it matters big time starting around $1/30$ of a second.

"How do you show motion when you have a still camera in your hands?
Rear curtain is the way to go."

*"Remember, babies are soft and cuddly.
Light accordingly."*

Baby shoots are tough. Ya gotta have lots of the little tykes hanging around, 'cause most of 'em aren't going to cooperate. "Next baby!" you end up shouting and the next eager mother steps up with Junior in her arms.

To do a good baby shoot, it actually helps if you've had a couple of 'em yourself. I had young assistants on this shoot, pre-fatherhood, and there were a couple of moments.

Like when one of the assistants brought the tot here onto the set, plopped him on the seamless background, and walked away. Poor little guy teetered upright for a moment and then the baby went BOOM!

"My baby!" screamed the mom, anxiously fluttering around him, while he didn't have a clue about the fuss. We got him comfortable and he performed like a champ.

Off to the side, I pointed out to the assistant that the baby was not a beer keg. He was a baby, and babies like to get sort of settled in and comfy before you leave them off on their own.

It's tough, though. To get the reaction you want, you have to do ridiculous things, and sometimes even be kind of a schnook. Like dangling a Cheerio in front of the kid and then, just as he reaches for it, snatching it away. I mean, you get a picture, but man, you feel like dirt.

How to Get This Type of Shot: Shot in a studio on a white seamless background. There's a big 30x40" softbox about two to three feet directly over the baby's head, aiming straight down. To fill in from the front, I used a big soft umbrella positioned to the left of the camera, moved in close. Given a soft, rounded dumpling of a baby, the kind of light to use is soft and rounded itself, so the whole idea is to bathe the whole set in light—kind of pouring the light right on him. Remember, babies are soft and cuddly. Light accordingly.

I spent seven fun-filled days with Donald Trump back in the roaring '80s. As I recall, he had a driver named Big Tony. I made friends with Tony. We made small talk about the Mets and the Yankees and I gave him a bunch of color neg film.

He would, in turn, tell me Trump's itinerary for the day and when he needed a car. So whenever Trump came down to get into the limo, I'd already be in it.

He didn't really want me in there, but he was too cool to make a scene. He would just give me that, "What the *#@! are you doin' in my limo?" look.

And off we'd go.

"Make friends with the people surrounding the big shot."

How to Get This Type of Shot: Shot with available light in the back of the limo, going across the Queensborough Bridge. There was hard light slashing through the bridge and coming through the limo's sun roof. As we drove across the bridge, we'd get: light/shadow, light/shadow, light/shadow. I kept my camera to my eye—every time I saw light, I hit the shutter. Total luck.

Donald Trump

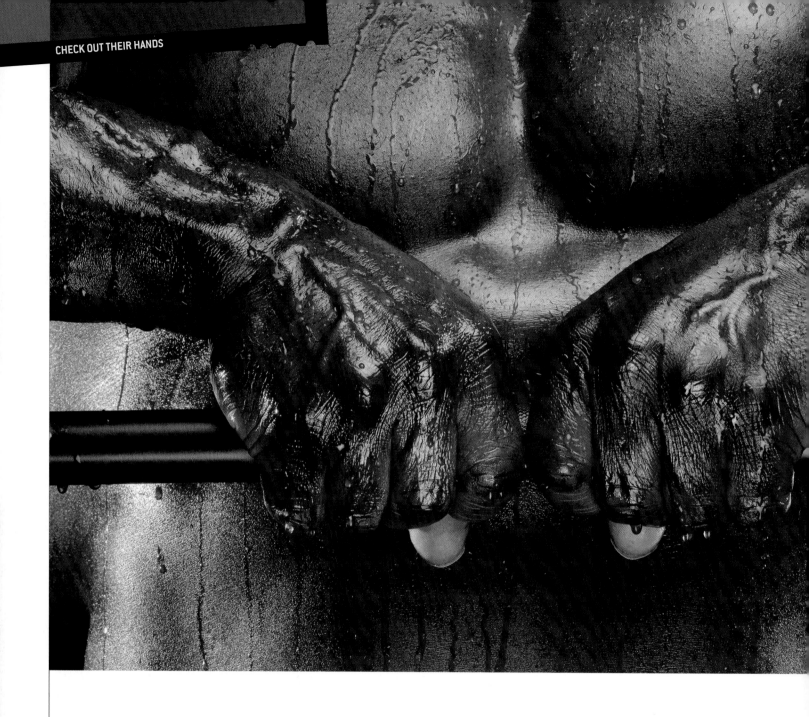

"When shooting a story about someone,
their hands should always be on your list to shoot."

Photographing hands has been one of my favorite activities, even to the point of suggesting to *Sports Illustrated* that we show a life in sports by photographing just the hands of the athletes.

They approved it, and then killed it during a budget cut.

It was fun while it lasted. Around the photo department, the story was affectionately dubbed "the hand job."

But ever since taking a class from *Life* DOP John Loengard all those years ago, hands fascinate me. When shooting a story about someone, their hands should always be on your list to shoot.

How to Get This Type of Shot: I lit Mr. Olympia Ronnie Coleman's hands with a beauty light combo. The hands are the center of attention, so directly above him is a medium softbox, slightly angled back toward his chest. The low fill light comes from a smaller softbox running at about half the power of the main light, positioned just below his hands. The key to the picture is the little "wing lights" on the sides that provide the visual separation. I used two Nikon SB-800 flashes positioned on either side of his body, just edging him out.

Top to bottom:
Amare Stoudemire
Ty Murray
Arnold Palmer

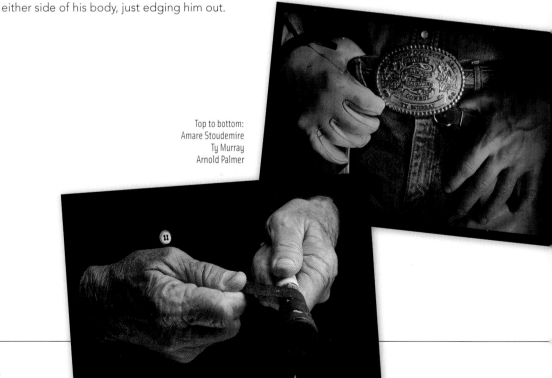

Ronnie Coleman

"Time was, you had to drag in the Polaroid and wander the room with an incident light meter. Now, we can just go click."

Just go click. That's a simple way of talking about an incredibly crucial, immediate thought process that has to take place when you show up. In more formal terms, we're talking location assessment.

Time was, you had to drag in the Polaroid and wander the room with an incident light meter, sorting out hot spots and shadows. Then you'd shoot a series of 90-second guestimates, wait for them to develop, and make some judgments based on material that was often off-color, lacked the same exposure range as the real film in the camera, and had marginal detail.

Now, we can *just go click*. That LCD! What an amazing thing and they're just getting better. Gives us a whole ton of information right away. You can see where dead zones are, how much or how little light to use, exact composition, shadow detail, histogram info, metadata, what you had for breakfast (kidding!), and the whole nine yards. (I always tell my classes, eventually they're gonna make a camera system so

intuitive that you'll do the first scouting picture and the LCD will return a set of messages instead of a picture. "Go elsewhere! You're screwed! You sure you wanna use *that* lens?")

You are now Polaroiding with exactitude inside the same camera you're gonna use to make the shot. No guesswork. No dragging out attachments or a whole other camera system with an accordion bellows that looked like you were in search of a good polka instead of a picture.

It doesn't matter if the first look is even a reasonable f-stop/shutter speed combo. It's information. It's immediate. It gives you a starting point. Think of it as the photo weather report. Is it gonna be a good day or a bad day?

How to Get This Type of Shot:
In this instance, I took an immediate look at my LCD after what I thought was too slow a shutter speed. It turned out, the camera's

brain was thinking right. There was tremendously hot noontime light out on the street, so my eyes were squinting and interpreting the scene as bright. The camera saw the fire truck as a light blocker, interpreted the scene as being dark, and spat out a shutter drag of about two seconds. That length of exposure enabled the sunlight to creep around the truck, off the ceiling, and through the windows, lighting the interior beautifully.

The back of the truck stayed dark, so that is where I put Louie, my subject. I put up one softbox, just for him, and the sunlight did the rest of the work. Without that instant info, I would have been messing with meters and Polaroids forever, and, it being a firehouse, most likely would have lost the shot, and one of my favorite portraits.

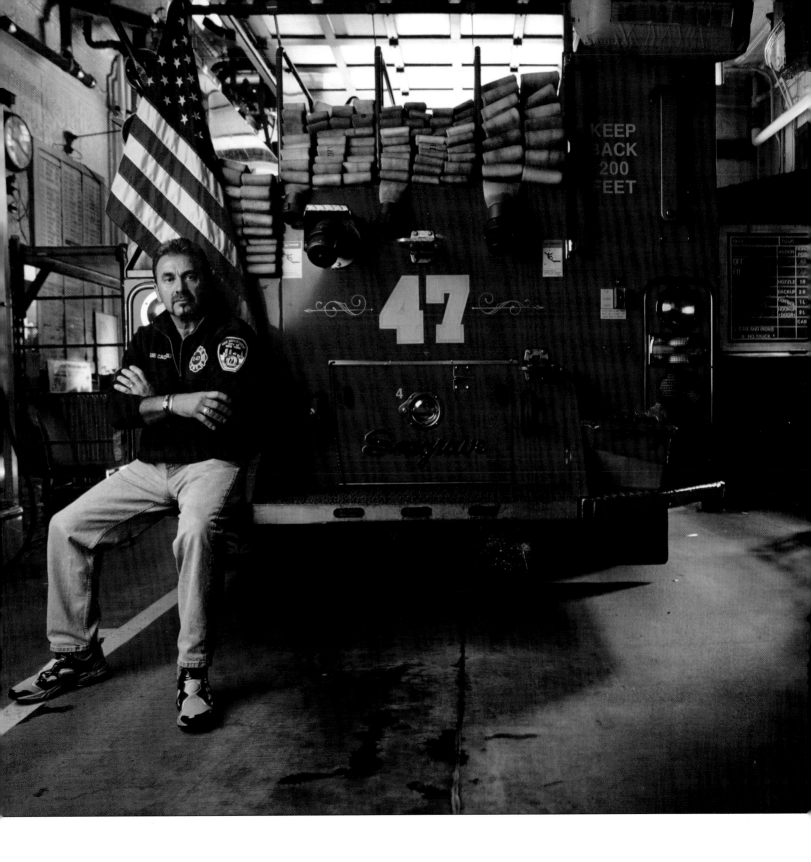

"To show scale, light the whole environment, and then highlight the subject."

I was working in Star City, the Russian space training center. It's a place that, during the Cold War, was not on any maps. Now, in the spirit of openness and trust that exists between Russia and America—not to mention the sharing of technology, expertise, and the exchange of cold, hard cash—American astronauts and Russian cosmonauts live and train together here.

One of the challenges of the story was lighting the world's largest centrifuge by myself. ("World's largest centrifuge!" said my contact. "Thousand dollars, make it spin.") I didn't have that kind of dough, so I had to shoot it just sitting there. The key to the picture was to establish a sense of scale: tiny human being and monster machine.

Lighting is a good way to show scale, so I asked Wendy Lawrence, NASA's most diminutive astronaut, to get into the pod. I lit her with two large battery-operated strobes, drawing attention to her size relative to the machine. I threw a couple other large strobes behind the machine, aimed at the far wall to create some separation. I shot this with a wide-angle lens to establish how enormous this device is. The lights on her are gelled warm, which resonates well against the cool overall lighting of the building.

To get all this done, I first had to write a letter to the commandant, a formidable Russian by the name of General Pyotr Klimuk. The Russian assistant in the NASA Star City office was helping me translate, typing the letter in Cyrillic.

"What is your title?" she asked in her heavy accent. I told her I was a photographer. She shook her head vigorously. "Photographer does not write letter to General Klimuk. You must call yourself somesing else."

"Okay," I said. "How about 'project coordinator'?"

"Zees is better," she said, finishing her typing.

Sometimes (we can't help it) as photographers, we get to liking ourselves too damn much, and really think a great deal of our abilities and our place in the universe. Then we run into a Russian commandant and find out it's actually better to be a project coordinator.

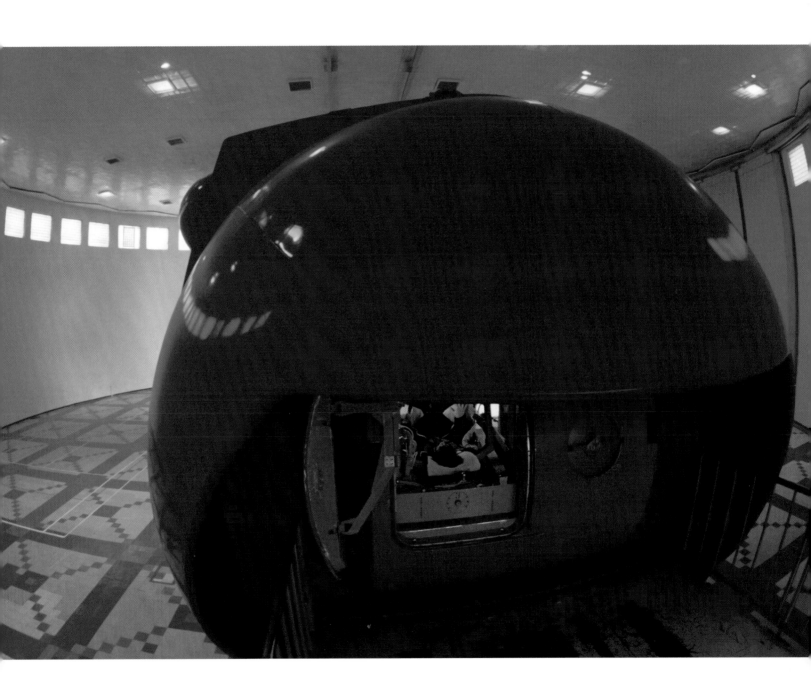

"Light speaks, just like language. You can make someone look like an angel, or the devil."

Do the math. You're not going to light the grandmother of the year for an article in the hometown *Daily Astonisher* with a ring light.[1] It doesn't matter if you just got the ring light from B&H and you're dying to use it.

Grandma's got to be lit softly, gently. Save the ring light for the local tattoo queen, or Mr. Lifto from the Jim Rose Circus. Light speaks, just like language. You can make someone look like an angel, or the devil. Take a look at Arnold Newman's famous portrait of Krupp, the German industrialist. Light speaks louder than words.

How to Get This Type of Shot: Lifto's an intense guy, so the light is intense. He's onstage a lot, and he's pretty theatrical, hence the light is low, mimicking the footlights of a theater, sparking his face and eyes. It's also a very controlled light, a head with a honeycomb spot grid[2] on it, so it does not spill evenly. Notice his hands and arms fade out of the highlight. The human eye wants to go to light areas, so my light tells you, stick with the face, that's where the action is.

[1] Ring Light: A circular light source that wraps around the barrel of the lens. Produces a hard, shadowless light. Very popular with fashion photogs.

[2] Honeycomb Spot Grid: A circular metal grid (that looks like a honeycomb) that goes over your strobe head and limits the spread of the light.

Mr. Lifto

When I was assigned to shoot Steve Martin for *Life*, I got my hands on everything Steve—his movies, profiles, any publicity. I knew I was not walking in on a "wild and crazy guy." I was walking in on a shy, diffident intellectual who would much rather I go away.

I had to give him something to chew on or act out. For me, his comedy always had a wince factor, an underlying sadness. That led to the tragic-comic masks and an in-camera double exposure.

I shot a Polaroid double of myself the night before in my hotel. This had two purposes: I could show him something and I could work the shot out—right down to the power ratios of the strobes, camera-to-subject distance, and f-stop. I couldn't waste time on location with that stuff, 'cause Martin was giving me four hours to fill six pages in *Life*.

Martin liked the Polaroid, so my assistant Garth headed to the basement to set up the double exposure. I tailed the comic through the house, shooting bits and pieces with available light. When the double was ready, we knocked it out in about 15 minutes.

Believe it or not, many actors/actresses are terrified of a still camera. Why? They can't act to it. There's no music, there's no dialog,

there's no motion, there isn't another actor to bounce off of—just an unforgiving machine staring them in the face. That was part of the thinking for the Polaroid: it gave him an outlet, he could act.

"Do Your Homework."

How to Get This Type of Shot: The shot was taken with three strobes: two camera left, one camera right, each positioned within one foot of his face, using small softboxes (1x2'). Both flashes were positioned slightly above his eyes and there is a low box for the left side of his face, softening the shadows and filling in his expression. I used smaller softboxes to control the light—I didn't want a lot of spill. Because I wanted to blend the two photos together, I wanted the light to hit his face and then immediately fall off.

This was done with film, but now it's easier to do a double exposure in-camera with digital. For example, on a Nikon D3, it has a double-exposure mode where you make one picture, the subject turns, and you just click again—it's just not that tough. The secret to doing this (moving fast) is the focus cursors: you want the focus cursor on the eye. When he turns, you move to the equivalent cursor on the left side and now you know the two faces are in register.

Steve Martin

"Remember, it's a game of inches. Even getting the light source out there at the end of the reach of your arm makes the light better."

Obviously, to avoid straight flash, you gotta get the light off the camera. Sometimes this is easy. Leave it hot shoed to the camera, crank it up, and bounce it off the ceiling. Or the wall. Or swivel it 180° and bounce it off the wall behind you.

Remember, it's always good to redirect the light. That can be very easy, or it can be a bear. With wireless TTL flashes, just keep a master flash on the camera and a remote flash in your pocket or camera bag. Pull that puppy out and start moving it around. Remember, it's a game of inches. Even getting the light source out there at the end of the reach of your arm makes the light better.

Unfortunately, I'm not Mr. Fantastic and I can't stretch my arm over a highway. Getting the light off the camera on this shot included a 30' boom, a heavy movie-style stand, a couple hundred pounds of sand bags, a whole bunch of rope, three assistants, my pickup truck, a hand-held camera flying along a couple inches off the pavement, a lead car to warn off oncoming traffic, some very illegal highway maneuvers, and a high-speed vehicle duet that was right out of *The Road Warrior*.

All to get that cheek shadow on the camera side of his face. Looks like he's drivin' west, headin' into the sun.

Straight flash? Highway heats up, the bike chrome gets nuked, and a lot of the tough-guy-on-the-chopper feel goes away. Straight flash makes him small, something Mr. Welbourn, an offensive lineman in the NFL, is very definitely not.

"Looks like candlelight.
It works, and it won't cost you any dough."

Take this to the bank when shooting candlelight: ISO 400, $1/15$ second, f/2.8-and-a-half. Give or take a smidge (technical term). Flash settings: dial −2 EV (exposure value), and put half-cut of CTO (an amber/warm gel) over the flash head. That's it. Looks like candlelight.

This tip is better than "Foxy Lady in the third race at Belmont." It works, and it won't cost you any dough.

Just remember to stay close to the candle. And remember, the candle is warm, yellow light. The last thing you want to do is blow that away with a strong, neutral white light. If you do that, you are setting up a psychological disconnect for the reader. Instead of getting involved in the photo, the reader says, "Huh?" Lighting is all about feel and color, and in this soulful, quiet situation, you feather the light in, and you stay away from the settings on the strobe that say "jackhammer."

"Never underestimate the floor as a light source."

Ever look at your subject and wonder why their face is all aglow with the light? It's often because the light is coming from below. Look around. The light from the door or from the window… is it hitting the floor?

Never underestimate the floor as a light source. Set up your main light. Look average? Need a little glamour? A little fill? Throw a Lastolite panel[1] on the floor…or a fill board…or a bed sheet. Bounce a light into it at –2 EV off the main light value.

Presto. Your subject's face starts to come alive, those undereye shadows soften, and your average executive, well, I'll stop short of saying you'll turn 'em into George Clooney, but it's helpful, let's put it that way.

Don't try this if your subject wears glasses. We're talking hit city, bad reflections. But, if your subject is a high-fashion model in Shanghai and you're shooting her in a hip nightclub, hit the floor and go for the glow!

[1] Lastolite Panel: A kit that has both diffusion and reflective material that fits onto a rigid, collapsible frame. Comes in 3x3', 3x6', and 6x6' sizes. Ideal for diffusing or flagging light sources, or simulating window light. Breaks down into a small, light duffel bag. Very roadworthy.

Always remember, being in front of the camera is a very vulnerable place to be and nothing makes your subject more queasy than to just be out there, alone, while you and the assistants hover, pace, look shaky, and talk pixels and f-stops. So radiate confidence!

It's always amazing to me how a crew can voice doubts and talk techie, worrisome crap right within earshot of the photo subject. I always imagine it's like the operating room chatter during a long, serious surgery. That doesn't matter to the patient, 'cause they're knocked out. But your subject is right there, listening. If you're fretting, so are they. "Is it all right? Is it serious? Am I gonna die?" Not good.

Think of it this way. You're a passenger on an airliner, some green co-pilot is accidentally sitting on the intercom switch, and you hear somebody in the cockpit say, "What's this button do?"

After 9/11, I shot Mike Piazza (for *Sports Illustrated*) sitting on the edge of a roof, 12 stories up, smoke in the skyline where the World Trade Center used to be. He and other New York athletes had stepped up to encourage and support the city.

"Your subject is right there, listening. If you're fretting, so are they. 'Is it all right? Is it serious? Am I gonna die?' Not good."

During the shoot, my heavily sandbagged and roped off strobe unit literally blew up. Flames started shooting out of the softbox. Not smoke, flames. Big ones. It looked for a minute like I had painted the Octa with a set of low rider decals.

I walked up to Mike and shrugged. The assistants were scurrying about, pulling it down, putting out the fire. Told him we had another unit, we'd have it running in about five minutes. Relax.

Remember, as insecure as you are behind the camera, they are doubly so in front of it. So, even though things are going to hell in a handbasket, give 'em the old "this is just temporary, we've got it handled" look. Make 'em feel good. (Even if you just peed your pants!)

NEVER LET 'EM SEE YA SWEAT

Mike Piazza

"Every once in a while, it pays to listen to those
 annoying characters who are just waiting to tell you how to do your job."

"Hey photographer!"

Don'tcha just hate that? I know I do. You're out there with a camera and somebody just has to tell you you're missing it. Or, "Hey, look over here! 'Cause it's a really good picture."

I shouldn't hate it though. Listening to somebody like that resulted in my first widely published photo. It was halftime at a Syracuse University football game and I was daydreaming, camera in hand, looking up at the stands, trying to ignore the band.

These two guys on the fence started shouting to me, "Hey photographer, turn around, there's a guy in the band who's gonna drop his pants!" I spun around and sure enough, there was this trumpet player trundling along with his mates, pants down at his ankles.

I had a Nikkormat and an old 300mm f/4.5. I charged the field (camera to my eye) and squeezed a frame just as he was recovering his trousers. Didn't think much of it, really, except that I knew it wasn't sharp.

Out of focus or not, it hit almost every paper in the country—even *People* magazine. Turns out it was a preconceived prank, for which the trumpeter was, as one account put it, "unceremoniously drummed from the band."

Every once in a while, it pays to listen to those annoying characters who are just waiting to tell you how to do your job.

It never hurts to look.

"There is a logic to light. It's gotta come from somewhere, and something has to be making it."

Steven Spielberg can get away with hot, smoky light coming from beneath the lost Ark of the Covenant, buried for 2,000 years in a crypt. We can't.

There is a logic to light. It's gotta come from somewhere and something has to be making it. That's why it doesn't really make sense to have somebody in a field staring at a hole in the ground with light coming from the hole. Unless you're shooting production stills for *The X-Files*.

Try to be logical and give your reader something to hang onto. I often use a flashlight, which creates a reason for the light, plus it's something you'd actually use if you were looking under a car hood, reading a map, or checking out a torpedo tube.

How to Get This Type of Shot: Small and light is the way to go onboard a sub. I brought three small SB flashes with me, bounced one to open up the dark recesses of the torpedo room, and then placed a double-gelled unit inside the tube, lighting the sailor's face.

"I mean, it was a long line, kind of around the block. Have to admit, I was feeling pretty good about it. Jay fixed that."

It's good to have friends and mentors who keep you in line and keep your head on straight. Jay Maisel is such a friend to me, in addition to being a font of wisdom and an incredible talent.

I was doing a poster signing for Nikon at PhotoPlus one year, and I had a big line waiting for my signature, apparently oblivious to the fact that when I sign something, the value actually diminishes.

I mean, it was a long line, kind of around the block. Have to admit, I was feeling pretty good about it. Jay fixed that.

He saw me and motioned me over. "McNally," he said, in his best Brooklyn accent. "McNally, I saw you had a big line for your poster. That's nice. But don't get a big head, McNally. McNally, if you were charging a nickel…no, no, wait…if you were charging a penny for those posters, there woulda been nobody on that line, McNally, nobody."

You know something? He's right.

You know something else? White's tough to shoot, especially on digital. Especially white on white on white.

How to Get This Type of Shot: Always remember, any meter, no matter how sophisticated, wants to run home to mama, who's wearing 18% gray. Most camera meters will look at this scene

and give you a middle gray. They're predisposed to give you a classic histogram with the bell in the middle.

You don't want that. You want high-key. You want a histogram that's screaming, "Danger! Danger, Will Robinson! You are approaching Ice Planet 255, where there is no sustainable life!!!"

Laughing in the face of danger, this is where you step forward and fly the ship. Program in +1 EV. That will pull your exposure to the right and give you the white you are looking for. Bracket your EV. Experiment. Find the limits of the file. Push it right to the edge and that's where your best white lives.

Usually the rule is to get your subject away from the background (to minimize shadows on the background), but here I placed her right up against the background, where the shadows fall sharp and hard. So why did I do this? Simply, I had seen it done and I wanted to try it myself. I wanted to play. A lot of fashion gets shot this way, and although this was shot in a daylight, rooftop studio in Miami, I assisted the available late-day sunlight with a huge 12k daylight-balanced movie light positioned behind me and to the camera's right. The sunlight provided the overall light, but the movie light is what provided the crisp shadow.

The Observer of London assigned me to photograph Ken Kesey, author of One Flew Over the Cuckoo's Nest and the most famous of the Merry Pranksters. They evidently hadn't checked with him.

I arrived at his house in Oregon, which was sort of like Times Square on New Year's Eve—just more rural and fewer people.

At first, he ignored me. Then he avoided me. Then he wasn't gonna pose.

"Make it clear you're not leaving."

"I don't care how big the camera is, I won't salute it," he declared, saluting me instead.

Luckily, he had this great hammock on his front lawn and it was summer. I took a long nap. Came back the next day and did the same. Went to lunch. Came back. Took another nap.

Late on the second day, he came outside. "Wanna go feed the cows?" (On location, when your subject asks you a question like that, say yes.)

So Kesey and I started throwing bales of hay off the back of a moving pickup truck to a bunch of hungry heifers. "This stuff is like tai stick for cows," he said, taking a long pull on what distinctly looked like tai stick between his lips.

He relaxed after that, got in his Eldorado with his cocker spaniel, and I got a picture. I think he just wanted me to leave.

How to Get This Type of Shot: This is shot with available light—late afternoon, using a 20mm wide-angle lens.

Ken Kesey

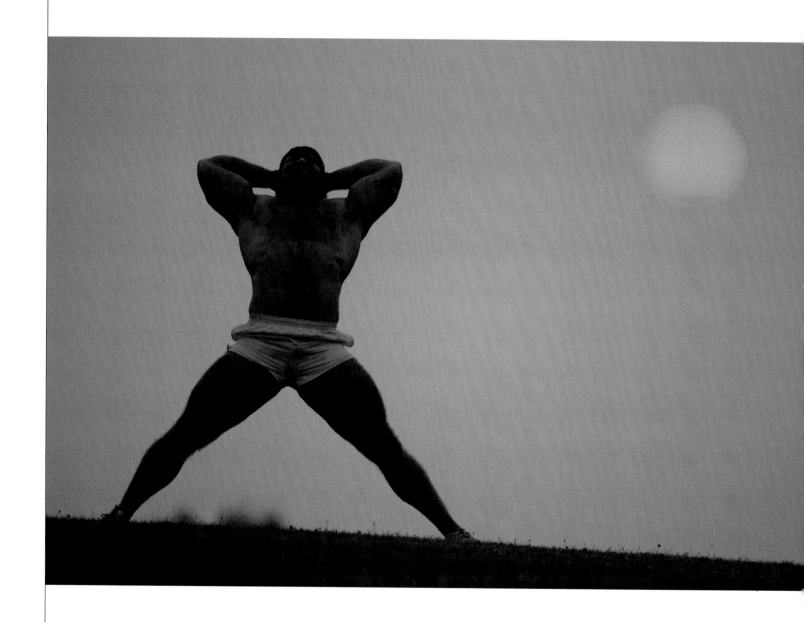

Mike Ruth

I occasionally went to the picture picking session at *Sports Illustrated*. When slides were shown, the managing editor at the time was generally the only one who spoke. He would sit there eating ice cream or generally snacking on something, and if he liked a picture, he would call out, "Yanko," meaning to yank it from the slide tray as a select. There would be a burble of approval around the room. If he *reeeeaaaallllllly* liked it, he would call out, "Yanko Supremo." More burbling.

I had never realized I was out there looking not for pictures, but for yanko supremos.

This one I believe got at least a yanko. Maybe even a supremo. The story was about Mike Ruth, a massive defensive lineman for Boston College and winner of the Outland Trophy as the nation's best defensive player. He was a surefire first rounder and big news, so I was dispatched to shoot some pictures.

Size is a tough thing to show in a photo, believe it or not. I was once assigned to photograph the biggest guys in the NFL, and I failed miserably. Biggest in relation to what? I put guys in meat lockers à la Rocky, on a bulldozer, lifting things, you name it. The only thing I got out of it was the biggest bill I have ever run up in a Red Lobster, when I caused the front line of the Indianapolis Colts to miss their training camp dinner. I had to spring for a meal. Each of them ordered two entrees.

"Remember to think like a comic book: low angle, look up! Turn your subject into a superhero!"

So, when I saw the summer sun dipping towards this hill and Mike was shirtless, finished with his workout, I grabbed a 400mm lens and asked him to go to the crest of the hill and do something athletic.

The pale haze muted the colors and made the sun shootable as a perfect round ball. Mike did some stretches, and I got a photo *USA Today* called the best sports photo of that week.

How to Get This Type of Shot: Couple of simple rules of thumb here: You have to get your subject to extend, and make their body a graphic shape. If they just go up and stand there, their silhouette will have no definition, and they will just look like a dark lump on the horizon.

Bigger is better here, in terms of lens. The bigger the lens, the more magnification and compression you get, and the subject and the sun get more impressive. (Low camera angle helps, too. Remember to think like a comic book: low angle, look up! Turn your subject into a superhero!)

It also helps when he's 270 pounds.

"Comic books tell wonderful stories. They have color, punch, drama, and great POV (point of view) on the action."

Bam! Splat! Pow! Aaarggh! Zoom!

I grew up on comic books. I went to five different grammar schools. Always the new kid. I had to find something to do besides get the $#!& kicked out of me during recess.

It informs my pictures now. Primary colors. Dramatic gestures. Screamin' light. I'm thoroughly unabashed about this. Comic books tell wonderful stories. They have color, punch, drama, great POV (point of view) on the action, and they make Zod, evil overlord of the Darthmanian nebula system, very real. At least for me.

So when I get the world's largest Van der Graaf generator in front of my lens, I'm in heaven. Or Frankenstein's castle. I'm thinking up a world of color, light, monsters, and heroes, and man, to borrow a phrase, "It's Clobberin' Time!"

A picture like this is a trip into the valley of the gels and the enemy here is white light bleed. That sounds like a horrible dermatological condition, but it is actually about the lighting, and generally results from being careless or lazy. When you want to just generally warm a scene up, for instance, it is cool to loosely tape warm gels on the strobe heads. Most of the light goes through the gel, some white light jumps out through open spaces between the gel and the head. No problem.

But, if you want rich, saturated color, ya gotta seal the light with the gel. Tape it on carefully and allow no open seams for white light to scream outta there. White light bleed will turn red pink, and give you punchless color.

Another point: when you don't have a good blue, for instance, a first, logical instinct might be to turn up the power on the flash. Want more color? Give it the gas! More power! No. Wrong. You make the color richer and stronger by dialing down the light. Less power, more color.

Eisie (Alfred Eisenstaedt) always used to say, bring the stuff with you, it doesn't do you any good back at the studio. He was right.

But just 'cause you got it, don't mean you have to use it.

I dragged a bunch of strobes to the roof of the Tropicana in Vegas to shoot Linda Donohue, the "Showgirl of the Year."

It was tough. Lots of stairs, wind, thunderstorm gathering, puddles of water everywhere. Makes you feel good about using large power packs.

"Just 'cause you got it, don't mean you have to use it."

I was so blinkered about using all this gear, thinking strobe, strobe, strobe, that I totally forgot I was there to make a picture. Wasn't the first time this had happened. I shudder to think about how many pictures I've missed while pursuing what I thought was gonna be the one. Sorta like dating, you know?

Anyway, common sense seized me and I looked at the subject, who was fussing with her feathers. A thought crackled through my remaining synapses…that looks fantastic! I put my eye into the camera and went click. We were done.

Thankfully the picture ran, and Linda was rewarded for climbing a 20-foot steel rung ladder in her dancing shoes, a G-string, and feathers.

Of course, if you think sweet, simple available light and you don't bring all this crap up there with you, you'll need it. Welcome to photography!

"Sometimes the Best light happens After the light is Gone."

You have to resist the urge to pack your stuff up when the sun goes below the horizon, because some of those last, lingering, luminous fingers of light can be some of the most beautiful of the day. You have to be careful when you work, because the light's real pretty, but there ain't much of it, so you're going to have to use a slow shutter speed. I was able to hand-hold this shot, with a one-second exposure, but I don't recommend this—this is where a tripod is your friend.

This is also the water trick at play again. Without the sheen of water as the waves hit the shore, there would be no separation, and no picture. The lengthy exposure helps here. As the water rushes along the beach, it is in motion, and the highlight spreads.

By the way, when you are stuck without a tripod, use anything you can get your hands on to stabilize the camera. Bill Allard at *National Geographic* is famous for using a beer bottle monopod. If there is nothing around, as there wasn't in this situation, sit down Indian-style and brace your elbows on your knees. Or, being at the beach, smush together a towel on the ground and nestle the camera in it. You sacrifice a bit of the ideal camera angle you might have wanted, but you get a frame.

Chapter Four—
There's Always Something
To Bounce Light Off Of

Chapter Four
THERE'S ALWAYS SOMETHING TO BOUNCE LIGHT OFF OF

Sometimes, you just gotta wing it. Got a job to shoot a photo portfolio of the overlarge freshmen NCAA hoopsters for *Sports Illustrated*. Started conjuring. One kid, Brandan Wright, had a wingspan of 7'4". Okay, Batman comes to mind. Magazine liked the wings idea, but wanted them white. Cool…just switched screens in my head to *X-Men 3*.

He doesn't even have to look at a schedule. Jimmy has always been a voice of reason and counsel to young photographers, an open door, and a shelter from the storm. Together, they are formidable and fight the good fight.)

So we got the wings at 11:30 in the morning for a 1:00 p.m. photo shoot. I was being allowed

"Magazine liked the wings idea, but wanted them white. Cool…now try finding wings for somebody six-eleven with arms that don't stop. It ain't easy."

Now try finding wings for somebody six-eleven with arms that don't stop. It ain't easy. My studio manager Lynn, who is a magical producer, started making phone calls and after a lot of dry wells, finally found the wing makers to the film and television industry, a small outfit in L.A. (where else?) called…Mother Plucker! I kid you not.

Money is a huge concern in any production, and these wings cost $3,400, last minute drop shipped straight to North Carolina. Steve Fine, DOP[1] at *SI*, called. "Can't you go to a Halloween shop?" he asked. I reminded him of the size of our subject. Got the go ahead.

(Steve Fine and Jimmy Colton are currently the best one-two punch in picture editing, by the way. Steve has the calculus of sports in his head. He knows that if LSU beats Auburn this Saturday, he has to move three photogs on January 3rd to New Orleans for the Sugar Bowl 'cause LSU will go up against Florida State.

30 precious minutes of this very important 18-year-old's life, no more. I had exactly an hour and a half to figure out how to hang these wings, stage and light the photo, and come up with at least two different solutions.

How to Get This Type of Shot: Okay. Usual deal. Speed lighting. Overhead softbox for him, small spot for background. Now the wings. Clamped 'em to the boom arm of a C-stand and sand bagged the heck out of it. Then put three strobe heads with magic arms on the same stand, all with honeycomb spot grids[2]. The whole rig looked like a science project gone bad.

Fanned the heads out desperately trying to get an even spread for backlight on the wings. They gotta look heavenly, right? So backlight's the deal. Got it close enough to work just as Brandan came around the corner. Retouching took it the rest of the way.

Like much location work, this one was truly a wing and a prayer.

[1] DOP is Director of Photography. He's the guy that controls my air supply—he assigns the story, has control over the overall direction of the photography, and is the main tap. Everything flows from him.

[2] Honeycomb Spot Grid: A circular metal grid (that looks like a honeycomb) that goes over your strobe head and limits the spread of the light.

Brandan Wright

"It's too bad ring light's gotten a bad rap, because when used properly and judiciously, it is a pretty snappy light that edges out your subject with the clean and definitive efficiency of a drill press."

The ring light[1] needs to be used…carefully. It has gotten a bit of a bad rap, probably from overuse in those downtown magazines with catchy names that usually last for about two issues and run page after page of disaffected, outlandishly dressed young people, apparently high on some form of illegal substance, staring vacantly at the camera with a circular highlight in their overlarge pupils.

It's too bad, because when used properly and judiciously, it is a pretty snappy light that edges out your subject with the clean and definitive efficiency of a drill press. Throw in a bit of hair, makeup, styling, a fishnet cat suit, a killer look, and oh my! Have to be careful tipping it around too much though, 'cause at an unfortunate angle it produces shadows that can turn even a shimmering sex goddess into something that dropped out of the ugly tree.

[1] Ring Light: A circular light source that wraps around the barrel of the lens. Produces a hard, shadowless light. Very popular with fashion photogs.

I was sent to the Southwest to photograph a Tyrannosaurus head for the cover of *Discover*.

Now this T. rex head turned out to be a realistic-looking, eight-foot hunk of polyurethane that was in the sculptor's garage, gathering dust. This is a typical assignment for me. Go make a national magazine cover out of a grime-laden piece of plastic.

We cleaned it, loaded it into a pickup, and trucked it out into the desert area, which was actually part of a national park. I rented a heavy-duty crank lift and a chainsaw, and got some rope and lumber. I'm an overgrown adolescent who saw *Jurassic Park* too many times and I wanted this puppy coming out of the trees, just like on the big screen. We found a tree, made sure no park rangers were around, chainsawed the $#!& out of it, and stuffed the lift in there. Then we took some of the branches and A-clamped them to light stands, lit the whole thing up Hollywood-style (shot at dusk), and got outta Dodge.

Tech Note: It was my first shoot with the Nikon D2X. Nikon had squirreled me away an early prototype. I'd been shooting with the D2H, and with my first few frames from the D2X, I saw the colors pop and knew, digitally speaking, we weren't in Kansas anymore.

"This is a typical assignment for me: Go make a national magazine cover out of a grime-laden piece of plastic."

How to Get This Type of Shot: A shot like this depends on really defined, colorful splashes of light. When using gels to create these colors, it is best to use honeycomb spot grids. This shot was "spot grid city." Big, broad sources of light don't work with gels, because the different colors overlap and bleed into each other. One spot with a green gel was just out of frame by his eye. There's a light with a tight grid and a red gel in the tree lighting his neck. There's a Nikon hot shoe flash inside his mouth—in the lower jaw—giving some detail to his tongue, and there's another spot grid to the left of the camera lighting his nose and upper row of teeth. This shot was taken with a 12–24mm wide-angle zoom.

I get there early. What can I say? I was raised Irish Catholic, so I feel guilty about stuff I'm not even responsible for. If I'm not in the parking lot two to three hours ahead of my appointment or assignment, I feel guilty. If I'm ever outright late, I feel like I gotta recite a frikkin' Novena.

This has benefits as an assignment shooter. You get the best parking spots at events, for instance. The security guys can't believe you just showed up at 6:00 a.m. for an event that evening, but no matter. So many people think I'm odd, I've given up worrying about it.

You have to choose your strategies here. Years ago, I was assigned to cover the circus-like trial of Sid Vicious in New York City, which basically meant hanging around the courthouse all day to no photographic avail whatsoever. I mean, there were no pictures except for some of Sid's punk friends who were hanging around as a show of support for their crackpot, unwashed, misogynist leader in spirit and kind. So I followed a group of these into the greasy spoon of the courthouse cafeteria, sat at the counter across from them, and ordered coffee. After a moment or two, I quietly snapped a frame with my Leica. This produced a baleful glare. Another snap.

"Turned around, and there was Jason Robards rehearsing his lines. Stuff like this happens in New York when you're there early."

Even for local jobs, it's good to get there early. In New York, I was assigned to shoot a bunch of actors doing public readings in an effort to save some of the older, historic Broadway theaters. It was cool. Some very famous theater people gathered and gave stirring public readings to save the old playhouses.

Didn't work, of course. Money was at stake, and when that goes down, even having Lauren Bacall on your side don't matter. The furry creative types are swell, but it was like sending shovel-toting peasants up against the Vikings.

The theaters went down, but the readings were great to shoot. It was like having a play for free right there in the street. I got there way early and ducked into a coffee shop, eternal refuge and impromptu office of the freelancer. Turned around, and there was Jason Robards rehearsing his lines.

Another glare. Another snap, and this time a snarl: "If you fookin' take another photo of me, I'll fookin' kill ya!" At this point, I'm in for a penny, in for a pound, and I reach down to my camera bag and pull out a motor-driven F2 with a Vivitar and start pounding flash pictures. He came right over the counter at me.

There are, perhaps, better ways to break the ice. Like walk right up to your subject and ask.

Mr. Robards couldn't have been more gracious, or more wonderfully oblivious to being photographed.

Stuff like this happens in New York when you're there early.

Jason Robards

I was such a rube when I came to New York that it really became a classic case of the lord looking after a fool. I knew so little, I didn't know that young photographers, fresh out of school with no experience, weren't really supposed to call the photo editor of *People* magazine.

John Dominis, legendary *Life* shooter, was the editor at the time. I was told that Mr. Dominis didn't "see" anyone. I could drop off my book.

Okay, but I told them I needed it back later that day 'cause I had other appointments. The term "cheeky little bastard" comes to mind.

I called later and was asked to come right over. "Mr. Dominis would like to see you." I don't recall breathing as I raced across town. I arrived in his office a sweaty mess.

"You're pretty serious about your work, aren't you?" he asked. I said, "Yes, absolutely, sir." He threw me a stack of contact sheets. "Take a look and tell me what you see there."

I spent a couple of minutes, and I told him, honestly, I didn't see much. He slapped his hand on the desk. "I gotta wade my way through this crap every day! And some of my friends are shooting it!"

He then told me to get out of New York. "Nobody's serious about their work here anymore," he said.

He walked over to a picture on his wall of a lady, shot for the magazine, who made crazy cake decorations for a living. Predictably, her face was made up like a cake, frosting and all.

He turned to me. "See this picture? I use the photographer who shot this picture a lot, because she can get people to do stuff like this. And she's nowhere near as good as you are right now! But I use her and I'm not going to use you. 'Cause I don't think you can get people to do this! You're too serious about your work. You gotta get outta New York."

Wait! I can be funny! Man walks into a bar….

I remember just wandering the streets for awhile.

How to Get This Type of Shot: I often place my lights outside the room where my subjects are. The Lopez family is the first family of tae kwon do (second from left is Steve, a two-time Olympic gold medalist). They had this huge set of sliding glass doors that face the backyard, and I put some strobes out there aiming back inside. I put a 12x12' white silk over the sliding glass doors (by the way, 80% of the time I travel, that 12' silk is with me). I shot the strobes through the white silk covering the windows, which gave the effect of a giant softbox and filled the kitchen with light. To fill in, I used flash on a stand just to the right of my camera, bouncing off the ceiling and filling in the shadows at approximately −2 EV from the main value of the lights in the backyard. The dog's name is Ninja, by the way.

"You're too serious about your work. You gotta get outta New York."

There have been magazines and editors I have wanted a job from so badly that I told them anything they wanted to hear, agreed to just about any sort of expectations, just to get the work.

I mean, once you get the job, then you can work out the details, right? Details like, how to shoot it.

I had an appointment with an editor of a big picture magazine I was crazed to work for. I was a young photographer, sitting there, making conversation, and trying not to appear desperate. She was holding all the cards. I was ready to agree to just about anything. Although she was a terrific editor and great to work for, she had an exterior Teutonic iciness that could make you think you were standing at the Gates of Mordor instead of sitting in a picture editor's office.

"You look like outdoorsman, yes?" she asked in heavily accented German. "Yes," I gushed. "Absolutely. Live in a tree house, drink rainwater, and eat bark. Yep, it's the outdoor life for me!"

"Good," came the reply. "We have a story about fishing you would be good for. Do you like to fish?"

"Oh, yes." More gushing. "My dad used to take me fishing. Love it. Fish all the time."

"Good. We will call you."

I walked out of the office embarrassed and panicked. Her assistant picture editor was sitting outside her office. She knew me pretty well and had overheard the entire conversation.

"You don't know shit about fishing," she said quietly, not even looking up from her paperwork.

I put my finger to my lips and slipped out of the office. I didn't get a fishing story, but I got a story about the Sicilian puppet theater, much more up my alley.

"Tell 'em anything. Just get the job."

How to Get This Type of Shot: Get one older Sicilian man and a puppet, and drag them to the top of a hill...just kidding. Actually, it's not that far from the truth. This gentleman was a classic artisan, a maker of puppets, and I wanted to get him and one of his prize creations out in the Sicilian countryside. Of course, we got desperately lost, and the sun was plunging to the horizon, so I pulled over at an outlook and pointed to some rocks. "Can you walk up there?" I asked. He nodded quietly.

This was shot with a two-foot-square softbox, set off to camera right, about five feet from the subject. I feathered it slightly, turning it a bit away from the subject, to the right. This would be called panning the head, or swiveling it right or left. In this case, I wanted some of the light to blow past him out into space, lest the bulk of the box hit the puppet, who is dressed in much lighter, gilded clothing than his dark suit.

I metered the sky and got a value just off the hottest part of the sunset. If you meter the hottest part, the rest of your sky could get very dark, and you'll have no detail or context—just the hot core of the sunset. It's good to meter just off the highlight, in the beginnings of the shadows and the clouds. This will give the sky a more open feel. Nowadays, the camera meters are very good at doing this, and really averaging out the overall sky in an even way. But always remember, looking at the sky and clouds like this is a good opportunity to play with your plus or minus EV value.

He looked to the heavens and got the puppet in position. I was completely, desperately unaware of it at the time, racing the light, but what I've always liked about the picture is the play of scale between his hands and the puppet's.

The hardest thing about lighting is not lighting. We're talking control of light here—lighting this, but not lighting that. The problem is that light from a strobe likes to party—it pretty much goes everywhere—and it's your job as photographer to be the cops, shut down the party, close the bar, and tell everybody to follow you.

I showed up to photograph Dr. Jeremy Nathans, whose work centered on color and the human brain. I had a couple of flashes with me, cameras, and a tripod.

Given Nathans' work, he had a bunch of color gels. I covered the lenses on two Kodak carousel projectors with swatches of primary colors and asked him to put on a white lab coat. I tipped the projectors so that the primaries crossed and became the complement on the white coat.

Now all this clever color would go bye-bye if I just set off a flash in something like an umbrella. Hello washed out, dramaless, crappy picture that won't get published!

I was always good with construction paper and tape back in grammar school, and things haven't changed much. I took one small Nikon SB flash and taped a tight honeycomb spot grid[1] over it. Then I took some gaffer's tape and cut the grid even further, making a small, controlled opening for the light. I positioned the flash directly in front of his face (the flash was clamped to a ceiling tile), with a quarter-cut CTO[2] gel on the flash to make the light a little warmer and add a little drama.

It ain't pretty, but it works.

> *"The hardest thing about lighting is NOT lighting. We're talking control of light here— lighting THIS, but NOT THAT."*

[1] Honeycomb Spot Grid: A circular metal grid (that looks like a honeycomb) that goes over your strobe head and limits the spread of the light.

[2] CTO: Color Temperature Orange. It's an amber gel, available in various intensities, that pushes daylight towards the warm (tungsten) end of the color scale. A quarter-cut means you get one-quarter the warmth of the full gel.

Dr. Jeremy Nathans

"You know the standard rule of photography that states you shouldn't shoot people with a wide-angle lens? It's a rule meant to be broken."

Ever notice when you put a wide-angle lens to your eye, and it looks great, and you think you've got everything in the picture, you look at it later and you've got too much of everything in the picture, and the crucial elements are teeny tiny in the back of the frame where you can barely see 'em? Tom Kennedy, my editor at the *Geographic*, always told me to: "Push the wide-angle lens—go wide, get tight, fill the frame." What he means is that consistently shooting pictures from a middle distance, at eye level, is a one-way ticket to boring pictures.

You can push a wide-angle lens very close to someone's face and still see the street behind them—there's plenty of context. You know the standard rule of photography that states you shouldn't shoot people with a wide-angle lens? It's a rule meant to be broken. Open any magazine and flip through the environmental portraits— you'll see a horizontal, wide-angle lens used very close to the subject again and again.

Here's an example: at a workshop once, I had a lovely lady who was assigned to do a story on a boat captain. She was terrified of shooting people, and kept coming in with these wide-angle pictures that showed the whole boat with the captain doing something interesting that you couldn't see because he was the size of a pea at the back of the boat. After three days of this, I took her camera, walked up to her, extended my arm, and placed my hand on her shoulder. I said, "Today, you will take this camera and this wide-angle lens, and you will be no further than this (meaning the length of my arm) from your subject, all day." Her pictures improved dramatically.

Ivana Trump

We were photographing Ivana Trump back in her "The Donald" days, when she was running the historic Plaza Hotel in NYC. I had the bright idea of photographing her atop one of the horse-drawn carriages. It was February.

I shot a few frames and she looked over at me and said, "Dahhhling, don't keep me out here too long. I don't want to catch ammonia!" Subjects sometimes say some pretty nutty things, and my advice is always just to smile and nod, and keep shooting.

I didn't bring her out in the freezing cold for no reason. Nor was the horse-drawn carriage an accident. In New York, the historic façade of the Plaza is instantly recognizable, and that hotel and the Central Park horse buggies go together like pastrami and rye, Frazier and Reed, Empire and Chrysler. They are inseparable, quite unlike Ivana and the Donald ultimately proved to be.

Like most celeb shoots, especially those where the famous subject is shivering, it was over in minutes and consumed less than a roll of film. She's standing in shadow and the building is in hot light. I put up a mid-sized umbrella on camera left, bumped her exposure up by at least three stops to bring her in register with the sunlight up above her, and blasted away.

Coulda kicked myself later, though. Shoulda used a softbox. The umbrella is lighting her okay, but also heating up the shiny surface of the carriage on the left of the frame. A more directional light from a softbox would have cured this a bit, as I could have then feathered it off to the right. (Feathering is basically rotating the light source right or left to direct the bulk of the light away from a potential hot spot. Nowhere near as effective a technique with an umbrella, 'cause an umbrella scatters light much more broadly than a softbox.) A flag, cutter, or GOBO would have helped, too. Or a winter jacket. Or a newspaper. Stick just about anything between the strobe and a shiny surface and it will help take some of the heat out of it.

I didn't do it, of course, I was moving too fast. I didn't want to catch ammonia.

Smile and nod.

"Stick just about anything between the strobe and a shiny surface and it will help take some of the heat out of it."

"If you want to be a better photographer, stand in front of more interesting stuff."

My friend and colleague, Jim Richardson at *National Geographic*, has simple advice for anyone who wants to become a better photographer: "If you want to be a better photographer, stand in front of more interesting stuff."

So, what could be more interesting than a bunch of Munchkins?

You know, the original Munchkins. Somehow *Life* magazine got access to the last living Munchkins. The magazine had no idea how to shoot them. So I put 'em in flower pots. My editor told me I was a sick bastard, but hey, in *The Wizard of Oz* they pop right outta the garden, so I figured, why not?

I hauled in 300 pounds of topsoil to the rental studio. The studio people were *reeeeeally* pissed at me. Not only did it stink, topsoil got everywhere—like the cracks in the wood floor…the *white* wood floor. We were up until midnight with vacuums trying to get it out.

So the Munchkins pull up in this limousine. I meet them and we ride up to the seventh floor, alone. We get into the elevator and the door closes. I look around and, honestly, it was kinda creepy. I was trapped in a confined space with a bunch of Munchkins. I mean, I got an active imagination, and I started thinkin' about them turnin' on me, their little faces gettin' all mean-like and their lollipop-guild voices saying, "Okay, let's have the wallet, sumbitch."

How to Get This Type of Shot: This is obviously a studio shot and that's obviously a painted backdrop. When you roll one of these out on a studio floor, you freak (because it just looks so cheesy), but you can transform it with light and f-stop. In this case, there's a setting sun on the right, so I put a strobe with a honeycomb spot grid to narrow the beam and aimed it at that spot with a warming gel (I used a gel from LeeFilters.com—in their light rolls, it's their Daylight Conversion Half CTO [Color Temperature Orange] gel), which in this case turned the white strobe into the color of a setting sun. (By the way, a half-cut means that you get half the warmth of the full gel.) I also added a soft wash using a strobe fitted with an umbrella to just bring a little detail into the overall background (underexposed from the foreground subjects by about two stops). Throw in a bit of a shallow f-stop (like f/4) and the background softens and loses detail, which is exactly what you want.

"If you catch the light just right, you can throw it a long way."

Think of it as volley and serve with the sun. Find the right angle and you can just smoke a return back the other way.

You don't need much to do this. There's all sorts of springy, twisty, bendy, collapsible-type fill surfaces out there that compact real well and stuff in your bag. Lastolite makes a thing called a TriGrip reflector that gives you a handle to hold it with one hand while you shoot with the other.

But a piece of white cardboard will do. So will a bed sheet. Or a table cloth. Or a bunch of pieces of Xerox paper Scotch-taped together.

Just make the catch.

It's also advisable not to have your own gear in the picture. Some editors will get upset about that. In this instance, you can tell I'm using a fill card, 'cause it's poking into the left side of the frame. Oops.

Milos Forman

Tracy McGrady

"Stick with your subjects. Especially Athletes."

I was assigned to shoot Tracy McGrady, with the Orlando Magic, for a cover of a kids' sports magazine. We had it all set up for a simulated action shot on a seamless. I was working for a very enthusiastic, very young picture editor. I loaded a back and turned around. Tracy was gone.

"What's up?" I asked the picture editor.

"Oh, he's just going into the locker room. He said he'd come right back and then we could go to his house!" he said excitedly.

I looked at the ground, shaking my head. "He ain't comin' back."

"No, really, he said we could come to his house, he'll be back…."

Both of us stared in the direction of the locker room where our star disappeared. I only had a few frames and I knew Tracy was already halfway to his house in a gated community outside Orlando. Gone. Shoot was over. Cover never ran.

Young athletes. Stick with 'em. Always remember they'd rather be playing *Halo*.

How to Get This Type of Shot: This was shot in the arena and I positioned a blue paper seamless background behind the basket. The key to this picture was lowering the basket down to where it was just six feet high, so he could just stand there and make like he was dunking. It's a very basic setup: one strobe on him positioned to the left of the camera and up high and a second strobe behind him aiming directly at him to give him a tiny bit of backlight.

I was in this glitzy hall of mirrors that was the main office of cosmetics maven Georgette Klinger, shooting a business feature for *Forbes* magazine, and there was a spiral staircase where we couldn't use a softbox or an umbrella because the mirrors would have picked it up. Luckily, I had a bounce card (a 3x4' piece of white cardboard) with me and I had my assistant stand just out of the reflection in the mirrors, where he held a small flash and bounced it off the card, which filled her just enough. It ain't great light, but sometimes "just enough" is plenty.

In tough situations like this, I take inspiration from one of my photo heroes, Jim Stanfield, who tells a story about being on assignment for *National Geographic*, shooting an ornately dressed bride in a cavern of a church, with only one flash in his bag. He really had nothing to bounce off of (Jim being Jim, he knew that straight-on flash equals no picture). His solution: he called the groom over and had him open his suit jacket, so he could bounce his flash off the groom's white shirt. He got a terrific frame.

This ain't rocket science.

Jim, by the way, could outshoot most of us with one eye shut and a bug in the other. If you want to know how to be an all-purpose, can-do-anything assignment photographer, study his work.

"Jim being Jim, he knew straight-on flash equals no picture. He called the groom over and had him open his suit jacket."

Georgette Klinger

"There was a big window and a little window. In my photographer's brain, that translated into Main light, Fill light."

There is nothing like the light in an Irish bar.

On the east coast of Ireland, the soft window light makes everyplace you go a studio. Legendary Irish writer Frank McCourt was sitting there and I noticed there was a big window and a little window. In my photographer's brain, that translated into main light, fill light.

I posed Frank against a dark wall with the windows on either side. It took about a minute to shoot at ISO 400 and we've made 24x30" prints of this frame.

Stuff like this happens and it convinces me all over again of two things:

1) This digital stuff really works.

2) Autofocus is really handy when you've had three pints of Guinness.

Frank McCourt

"Straight flash is Disaster Light."

Straight flash is disaster light. Use it at 3:00 a.m., with bodies on the highway, and nothing to bounce off.

Jerry Seinfeld has a funny routine about guys who are desperately trying to meet girls but can't figure out how. He talks about the guy who sits in his car and honks his horn at women. As he very rightly points out, "This is a man who has run out of ideas."

As photographers, when we use straight flash, we're that guy.

We're in the cavern of a casino—nothing to bounce light off of—straight flash was the only way to go. In this case, the picture sucks, but the personalities saved it. And believe it or not, this picture got published in *Newsweek*. The mantra of editoral photographers is "get the shot"—even if you know it's going to suck, when you have an array of personalities like this, you have to put the camera to your eye.

That being said, any light that originates at the camera is de facto unflattering—you're literally throwing light at your subject. You're not making a picture, you're making a copy. It's a game of inches, even if I can only get the flash off the camera by a few inches (to the left or right of my camera), I know I improved the quality of my light. I always tell my students: when you use straight flash, you turn your camera into a Xerox machine.

Tyrell Biggs, Donald Trump, Don King, Mike Tyson

"Pray for bad weather. It makes for GOOD pictures."

When my students go out and see a cloudy day and sigh, I tell them, "I love this weather." When there's clouds, there's soft light, and that means there's texture and shape in the sky—not just a bald blue. This lack of light gives you enormous control, if you're using flash.

On a bright, cloudless day, it's close to impossible to overpower the sun. Put a rack of clouds up there and you've got an instant softbox in the sky, and then by introducing your own light, you can easily use the cloud light as either a main or a fill light.

Things like raindrops on windows are a wonderful thing to shoot—and there's never been a better time to shoot on a rainy day, thanks to new camera technology (as some bodies are now sealed against moisture) and a whole range of camera rain covers from companies like Kata.

How to Get This Type of Shot: This is where your ability to focus comes heavily into play. I'm not talking about the lens (more on that later) but I'm talking about upstairs...mental focus. You're cold, you're wet, you're miserable, you're worried about your gear, and the last thing on your mind is the shot. Hot coffee at the press bar is looking like an awfully good option. But stick with it. Sports-shooting great Neil Leifer made some of his best pictures out of lousy conditions and lousy light.

Play with the rain. That may sound ridiculous, but try holding your long lenses at slower shutters like a 1/60 or so. You can get moments when the players are sharp and the rain, especially heavy rain, whips through the frame like tracer bullets. You actually turn the rain to your advantage, and make it a stylistic element of the photo. This is where Continuous High on your advance options comes to your rescue. Burst the camera. Shoot lots of frames. Accept that certain stuff will be out of focus.

And, speaking of focus, be careful. Heavy rain can play havoc with autofocus, so you may occasionally have to go back to doing it the old-fashioned way.

"You are not going to be in the room when people look at your pictures. Your picture has to speak for itself."

I always tell my students, and I really try and hammer the point home, that you are not going to be in the room when people look at your pictures. The picture has to speak for itself. No matter what your experience of that day, no matter what you went through to get that photo, it doesn't make a bit of difference to someone who's looking at that photo, unless the photo carries the experience.

For a shot to really work, it's got to be successful pictorially, informationally, and emotionally. Face it, we're emotional creatures—we come back with these pictures we took, and we're like the six-year-old in kindergarten running up to the teacher with our scribbling and saying, "Look what I did! Look what I did!" Just because we're excited about it, doesn't mean it's not scribbling.

So when you're in the field—think like a photo editor. The best quality a photo editor brings to the table is dispassion. It sounds cruel, but they don't give a rat's @$$ if you had a bad day, or the boat capsized, or people were mean to you. All they care about is the picture: does it speak or does it not? If you think like a photo editor, your pictures will get better because you won't go easy on yourself. You have to be your own toughest critic.

This portrait of Leonard Bernstein composing at the piano has always been one of my favorites. No explanations are needed. The room feels like music.

How to Get This Type of Shot: This is where "just go click" comes into play. Get the angle, lock down the camera on a tripod. In other words, get your point of view. Once you have a look at the scene, you'll see the window light is doing an awful lot of the heavy lifting for you. All you have to do is amp it up a bit, tweak it, push it, pull it. First step was to open up the room a bit. The window light was nice, but it was backlight, and lot of the furniture was going dark. So I threw a little light back at the scene with a weak bounce (about one stop under the room exposure) off the ceiling to camera left.

Then I had to open up the camera-side of Lenny's face. I did this with a weak umbrella, placed off to camera right. You can see the shimmer of it in the window in the upper right of the frame. But the secret to lighting Lenny was to key his face and mimic the light of the music lamp on his piano. I helped myself out by taking that little tungsten work light and pushing backwards so it hits the sheet music, effectively making the music a fill card. You can see how hot it's getting, right on the edge.

Then I took another strobe head and put a super-tight honeycomb spot grid (mentioned before in this chapter) on it, and a half-cut of CTO (warming gel, also described elsewhere) and stashed it out of sight, way to camera right behind the piano, looking at Lenny. A little pop out of that and I was able to get control back of the blown highlight on the sheet music.

The result is that the room is lit without looking lit. In lighting situations like this, all you really have to do is get out of your own way.

Leonard Bernstein

There have been times in the field when I don't remember breathing. This girl was blinded by her boyfriend, who shot her in the head twice. She is "seeing" her first horse.

This moment can't be orchestrated, won't come again, and reminds you of why you are a photographer. It's never been published.

Sometimes I am asked why a white horse has a yellow nose. The window light is bouncing off bales of hay. Light picks up the color of what it hits.

I shot this with a Leica, because in an emotional, quiet scene like this, you don't want the sound of a motor drive to destroy the atmosphere or spook the horse.

"Light picks up the color of what it hits."

How to Get This Type of Shot: This was taken using natural window light—no flash—with a 35mm lens on a cloudy day. I was thankful for the cloudy light. If it had been sunny, all the detail in the fur would be gone.

Ever notice how a conversation with a photographer goes something like, "That's enough about me, let's talk about what you think of my work!"

We're mildly self-involved. Especially after you've worked on a *National Geographic* story called "Sense of Sight" for the better part of a year, and it gets the cover and runs 40 pages. I was very proud of it. I wanted to show everybody my prize tray of slides. "Wanna see my sight tray?" became the extent of my conversation. Didn't matter who you were. The poor FedEx guy would show up with a package. "Wanna see my sight tray?"

After that story, I put my feet up and waited for the phone to ring. And waited. And waited some more. Never happened. I had spent so long and had dived so deep into the story, I had to go out and pound the pavement, reminding people I existed.

It was a long haul before I got any work again. Bills were mounting. Couldn't pay 'em. It was bad. Not a happy household. Tense, in a word. I was on the phone with American Express, telling them they'd get their money real soon. My now ex-wife called out from the kitchen, "Why don't you show them your sight tray!"

Lots of lessons learned. Including the wherefores of a shot like this, which is basically spit, glue, and a whole bunch of luck.

How to Get This Type of Shot: I needed a picture that defined sight. I thought a shot of a procedure like this might cut it. It's lit with one hot shoe flash, camera right, slightly behind the subject. (If the subject's eye is 12 noon, the flash is at two o'clock.) All it is doing is edging out his nose and defining his eye. I controlled the spill of the light by making a snoot[1] out of gaffer tape.

Now for the laser. You generally can't see a laser unless it hits particulate matter in the air, so one good non-toxic solution is dry ice vapor. All you need is a subject who can keep his eye open for 30 seconds (the exposure was a complete guess) with a laser beam going in it, a flash going off, and a cup of dry ice vapor being poured down his forehead. Luckily, this gentleman was studying Zen Buddhism.

I shot one roll of Kodachrome 200. One frame worked, a mighty lucky one at that. After a year on the road, 1,500 rolls of film and many, many thousands of miles in the air, the lead shot came down to a high-tech Hail Mary.

[1] Snoot: Any device that forms a tube around your light source to funnel it and make it more directional. Could be a fancy Lumiquest store-bought snoot, or just some cardboard taped together. The function is to direct the light and control spill.

"Keep your camera near your Eye."

Steve Martin and I were on the beach and we were both like pilots who had lost airspeed, altitude, and ideas all at once. I knew the shoot was just about over.

"This year has gone really well for you," I said, reaching for anything. "Is there any way you can show me that?"

"Yeeaahhhh, but you know, when you physicalize an emotion like that, you tend to appear self-obsessed," he replied, grimacing.

A voice in my head was shrieking, yeah, that's the deal, you are self-obsessed!

And then he gave it to me, mostly because he thought I wasn't ready. My camera was off my eye, down at my chin, but pointed at him. He gave it to me for a split-second, which was actually pretty generous of him, 'cause he didn't want to do it. I squeezed off one frame without looking through the lens.

The two major pieces of any picture story are your opener and your closer. I just got the closer.

How to Get This Type of Shot: This was shot with just one portable strobe, connected to the end of a 3' monopod, and it had a small 1x2' softbox over it. This was held by my assistant, maybe three feet in front of him to the camera's left, and I was shooting in really close using a 20mm wide-angle lens.

Steve Martin

"I was Photographing this poor guy and his D.I. came up to him and started screaming, 'Oh good, they're gonna put you on the cover of Whiner magazine!'"

When stuff like this happens, man, you feel bad for the guy. You just have to remember that you are there doing your job, and he is doing his, and this is Navy SEAL Hell Week and all this misery would be going on whether you are there with your camera or not.

Speaking of misery, that is the name of the log these guys are hoisting. The boat crews for the SEALs routinely work out with and carry around the equivalent of a telephone pole. When they screw up, they get to meet a very special telephone pole, this 350-lb. pup nicknamed "Misery."

How to Get This Type of Shot: This is fill flash, by the way. Just a little, −2 EV or so. Without a small pop of light under that log shadow, his face will disappear, and your editor will bypass the picture in search of something more reproducible. That is a crucial part of your mission, not just to observe and shoot, but to make sure what you come back with can be printed.

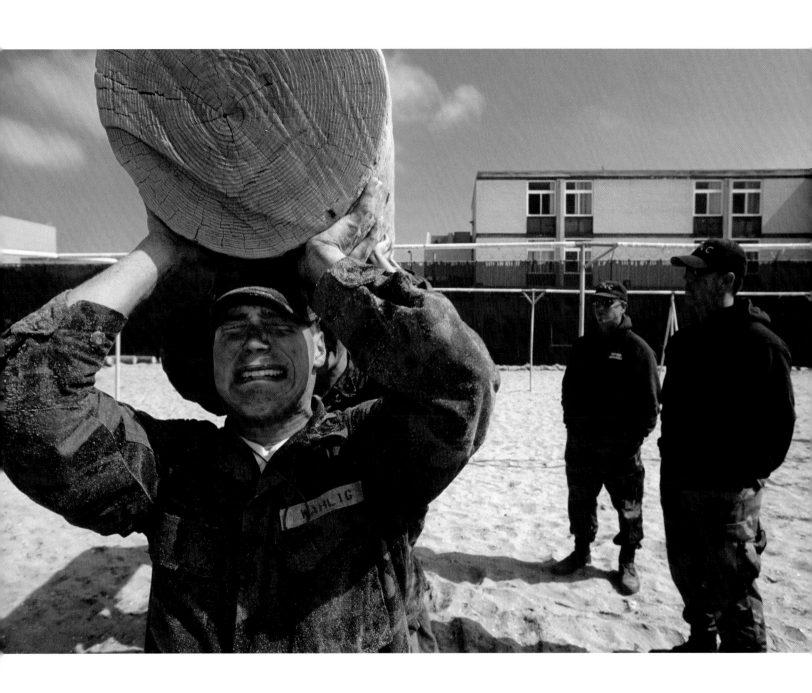

"In this image-crazed world of ours,
you need your pictures to shout."

Thinking up a shot like this, I feel like a carnival barker. Ozzie Smith! The Wizard of Oz! Looks like he plays shortstop from five different positions at once! See the bearded lady and the amazing fire-eating contortionist!

It makes sense, actually. In this image-crazed world of ours, you need your pictures to shout.

So how do you get a cool picture of this magical ballplayer? Mirrors!

Oh, boy. Mirrors are great, but they are fragile, heavy, expensive, and highly reflective. I always remember stuff like that too late.

We got them out to the infield okay. Got them tweaked and torqued, polished and cleaned, sighted and sandbagged. Ozzie was not in the picture, he was standing right next to the camera. He was lit with a strobe on a huge movie boom, flying overhead of the whole scene, just out of frame and looking back at the camera. I controlled the spill of light with a tight honeycomb spot grid[1]. Otherwise, it would have been flare city back at the lens.

Dusk was coming and I noticed something. Our white elephant of a grip truck was reflected in every mirror. A not-so-minor detail I managed to overlook while setting up.

Couldn't move the truck—all the power lines were running out of it. Okay, white reveals, black conceals! Quick race to the nearest fabric store. "Hi, I need to buy every yard of black material you have in this place!" Retailers love desperate photographers.

[1] Honeycomb Spot Grid: A circular metal grid (that looks like a honeycomb) that goes over your strobe head and limits the spread of the light.

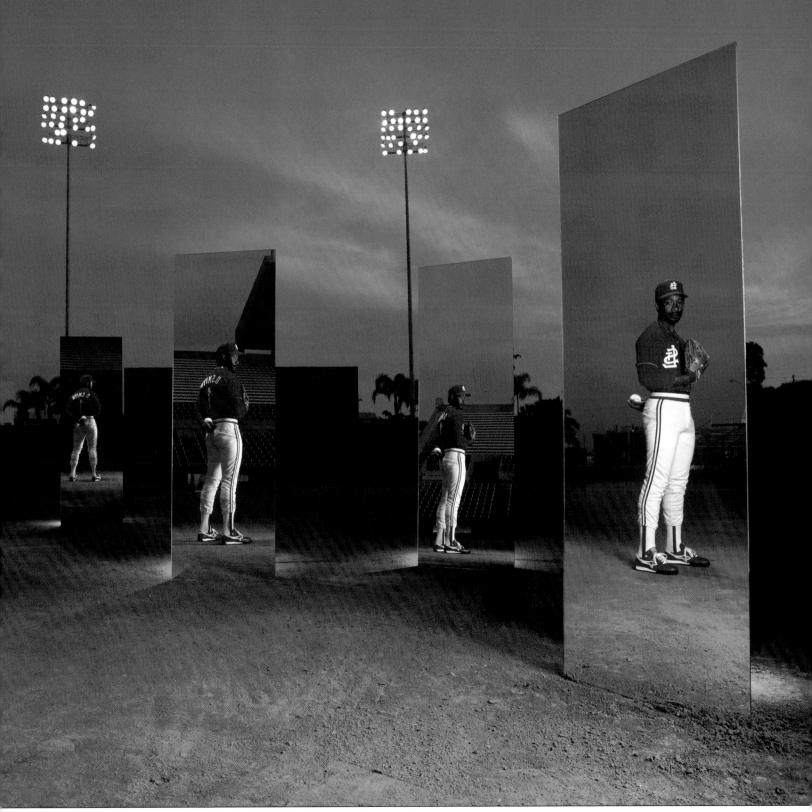

Ozzie Smith

Joe's Lighting Tips

Things to Remember When You're on Location and the Flying Fecal Matter's Hitting the Rotating Blades of the Air Circulating Device.

I have always thought of light as language. I ascribe to light the same qualities and characteristics one could generally apply to the spoken or written word. Light has color and tone, range, emotion, inflection, and timbre. It can sharpen or soften a picture. It can change the meaning of a photo, or what that photo will mean to someone. Like language, when used effectively, it has the power to move people, viscerally and emotionally, and inform them. The use of light in our pictures harks back to the original descriptive term we use to define this beloved endeavor of making pictures: photography, or *phot-graphos*, from the Greek, meaning, to write with light. Writing with light! Cool!

It's a big deal, right? As a photographer, it is very important to know how to do this. So why are so many of us illiterate?

Or more properly, selectively illiterate. I have seen photographers with an acutely beautiful sense of natural light, indeed a passion for it, start to vibrate like a tuning fork when a strobe is placed in their hands. Some photographers will wait for hours for the right time of day. Some will quite literally chase a swatch of photons reflecting off the side view mirror of a slow-moving bus down the block at dawn just to see if it will momentarily hit the wizened face of the elderly gentleman reading the paper at the window of the corner coffee shop. These very same shooters will look hesitantly, quizzically, even fearfully at a source

Continued

of artificial light as if they are auditioning for a part in *Quest for Fire*, and had never seen such magic before.

I was blessed early in my career by having my self-esteem and photographic efforts subjected to assessment by some old-school wire service photo editors who, when they were on the street as photographers, started their days by placing yesterday's cigar between their teeth, hitching up a pair of pants you could fit a zeppelin into, looping a 500-volt wet cell battery pack through their belts, and snugging it to their ample hips. Armed with a potato masher and a speed graphic (which most likely had the f-stop ring taped down at f/8), they would go about their day, indoors and out, making flash pictures. What we refer to now as fill flash, they called "synchro sun." Like an umbrella on a rainy day or their car keys, they quite literally wouldn't think of leaving the house without their strobe.

They brought that ethic to their judgment of film as editors. During the 1978 Yankees-KC baseball playoffs, I returned to the UPI temporary darkroom in Yankee Stadium with what I thought was a terrific ISO 1600 available-fluorescence photo of one of the losing Royals players slumped against the wall surrounded by discarded jerseys. Larry DeSantis, the news picture editor, never took his eye from his Agfa loupe while whipping through my film as he croaked in his best Brooklynese, "Nice picture kid. Never shoot a locker room without a strobe. I give this advice to you for free."

That advice was pretty much an absolute and I have survived long enough in this nutty business to know there are no real absolutes. Sometimes the best frames are made from broken rules and bad exposures. But one thing that Larry was addressing, albeit through the prism of his no-frills, big city, down and dirty, get-it-on-the-wire point of view, was the use of light. **What sticks with us, always, is light.** It is the wand in the conductor's hand. We watch it, follow it, respond to it, and

yearn to ring every nuance of substance, meaning, and emotion out of it. It leads us, and we shoot and move to its rhythm.

I could wax eloquent about how, in a moment of photographic epiphany, I discovered and became conversant with the magic of strobe light. But I would be lying. Any degree of proficiency and acquaintance I have with the use of light of any kind has been a matter of hard work, repeated failures, basic curiosity, and a simple instinct for survival. I realized very early in my career that I was not possessed of the brilliance required to dictate to my clients that I would only shoot available light black-and-white film with a Leica. My destiny was that of a general assignment magazine photographer, by and large, and **to that end, I rapidly converted to the school of available light being "any &*%%@^ light that's available."**

Because light is just light, it is not magic, but a very real thing, and we need to be able to use it, adjust it, and bend it to our advantage. At my lighting workshops, I always tell students that light is like a basketball. It bounces off the floor, hits the wall, and comes back to you. It is pretty basic, in many ways.

Given the simple nature of light, I offer some equivalently simple tips for using it effectively in your photographs. **Mind you, I offer these tips, Dos and Don'ts if you will, with the reminder that all rules are meant to be broken,** and there is no unifying, earth-encompassing credo any photographer can employ in all situations he or she will encounter. All photo assignments are situational and require improvisational, spontaneous responses. At this point in my career, the only absolute I would offer to anyone is to not do this at all professionally, chuck the photo/art school curricula you're taking that actually offers academic credit for courses called "Finding Your Zen Central," and get an MBA. (However, if you're reading this, it is probably too late.)

1. Always start with one light.

Multiple lights all at once can create multiple problems, which can be difficult to sort out. Put up one light. See what it does. You may have to go no further. (The obvious corollary to this, of course, is to look at the nature of the existing light. You just might be able to leave the strobes in the trunk of your car.)

2. Generally, warm is better than cool.

When lighting portraits, a small bit of warming gel is often very effective in obtaining a pleasing result. Face it, people look better slightly warm, as if they are sitting with a bunch of swells in the glow of the table lights at Le Cirque, rather than sort of cold, as if they had just spent the day ice fishing.

3. Study Your Location – Where is there already light? Where's it Coming From?

During location assessment, those crucial first few minutes you have when you show up on assignment and are looking around trying to determine how awful your day is about to get, look at where the light is coming from already. From the ceiling? Through the windows or the door? Am I going for a natural environmental look and therefore merely have to tweak what exists, or do I have to control the whole scene by overpowering existing light with my own lights? What does my editor or publication want? How much time do I have? Will my subject have the patience to wait while I set up for two hours or do I have to throw up a light and get this done? (Lots and lots of practical questions should race through your head immediately, because your initial assessment process will determine where you will place your camera. Given the strictures of location work, deadlines, and subject availability, this first shot may be the only shot you get, so this initial set of internal queries is extremely important.)

Continued

4. Do Your Reshoot Now.

When wrapped up in the euphoria (or agony) of the shoot, do a mental check on yourself. If you are working long lens, try to imagine the scene with a wide lens from the other side of the room. Or think about a high or low angle. Always remember the last thing most editors like to see is a couple hundred frames shot from exactly the same position and attitude. Move around. Think outside of the lens and light you are currently using. Remember, shooting two or three hundred frames with the same lens, the same light, and the same angle is, uh, let's see, how shall I say this? Repetitive and lacking imagination?

5. Never shoot a locker room without a strobe. (Just kidding!)

6. Remember, as an assignment photographer, that one "aw shit" wipes out three "attaboys."

7. Remember that the hardest thing about lighting is NOT lighting.

The issue here is control. It takes effort and expertise to speak with the light and bring different qualities of shadow, color, and tone to different areas of the photo. Flags, cutters, honeycomb grids, barn doors, gels, or the dining room tablecloth gaffer-taped to your light source will help you control and wrangle the explosion of photons that occurs when you trip a strobe. If you work with all these elements, and practice with them, you will soon see that in the context of the same photo, you can light Jimmy differently from Sally. A good subset rule of this is: If you want something to look interesting, don't light all of it.

8. A white wall can be your friend or your enemy.

White walls are great if you are looking for bounce, fill, and open, airy results. They are deadly if you are trying to light someone in a dramatic or shadowy way. I carry in my grip bags some cut-up rolls of what I call black flocking paper (it goes by different names in the industry) that, when taped to walls, turns your average office into a black hole, allowing the light to be expressed in exactly the manner you intended.

9. Experiment! You should have either a written or mental Rolodex of what you have tried and what looks good.

That is not to say that you should do the same thing all the time, quite the contrary. But, especially when you have to move fast, you must have the nuts and bolts and f-stops of your process down cold, so that your vision of the shot can dominate your thinking. All the fancy strobe heads, and packs, and C-stands, and soft-boxes you drag along with you should never interfere with your clarity of thought. All that stuff (and it is just stuff) is in service of how you want the photograph to feel, and what you are trying to say, picturewise.

10. Don't light everything the same way!

Boring! This would definitely be a close cousin to number nine. Clint Eastwood's face requires a different lighting approach than, say, Pamela Anderson's.

11. If you're getting assignments to shoot people like this, you don't need my advice.

'Nuff said! Good luck!

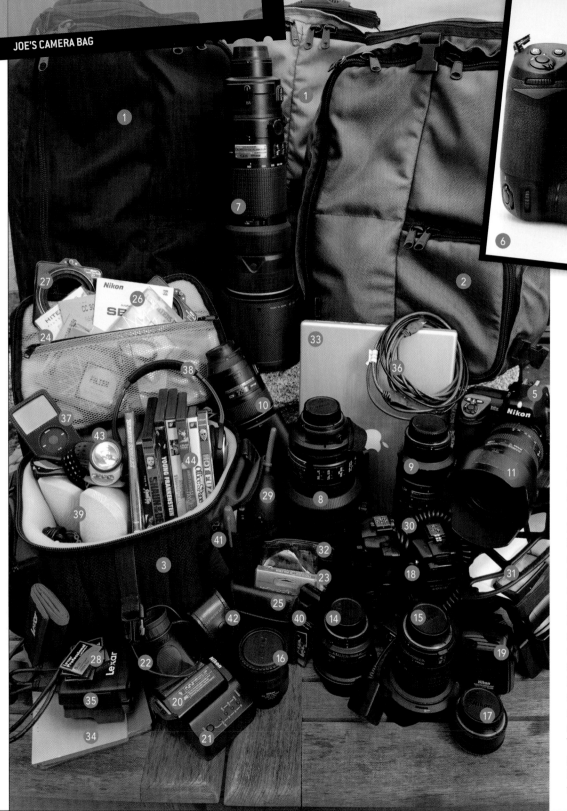

© Brad Moore

Nikon has been a definitive force in my career, and in the creation of this book. Their cameras and lenses are the finest in the industry. Many of the photos in this book are a testament to the dependability and excellence of Nikon gear, and its ability to perform under pressure in adverse conditions. Nikon products, technology, and innovation remain critical to my success as a shooter. To learn more about photography and Nikon products, please visit www.nikonusa.com.

Photo © Joe McNally

Joe's Camera Bag

Joe's Camera Bag(s)
1. (2) WRP MP-1 Backpacks
2. WRP MP-3 Backpack
3. KATA WS-604 Waist Shoulder Bag

Nikon Bodies
4. Nikon D2Xs (not pictured)
5. Nikon D2X
6. Nikon D3

Lenses
7. AF-S VR Zoom NIKKOR 200–400mm f/4G IF-ED
8. AF-S VR NIKKOR 200mm f/2G IF-ED
9. AF-S VR Zoom NIKKOR 70–200mm f/2.8G IF-ED
10. AF-S VR Micro NIKKOR 105mm f/2.8G IF-ED
11. AF-S DX Zoom NIKKOR 17–55mm f/2.8G IF-ED
12. AF-S NIKKOR 24–70mm f/2.8G ED
13. AF-S NIKKOR 14–24mm f/2.8G ED
14. AF NIKKOR 14mm f/2.8D ED
15. AF-S DX Zoom NIKKOR 12–24mm f/4G IF-ED
16. AF DX Fisheye NIKKOR 10.5mm f/2.8G ED
17. AF-S Teleconverter TC-17E II

Nikon Flashes
18. (5) SB-800 AF Speedlight
19. SU-800 Wireless Speedlight Commander

Camera Accessories
20. Nikon EN-EL4a Rechargeable Li-ion Batteries
21. Nikon MH-21 Quick Charger
22. Hoodman HoodLoupe Professional
23. Moose's Warm (81A)+PL 77mm Filter
24. Hitech 85mm 0.9 Graduated Neutral Density 0.9 Filter
25. Singh-Ray Thin 77mm Vari-ND Filter
26. Lens Filters (Kodak and Lee brands)
27. Nikon Gelatin Filter Holders
28. 8 GB Lexar Professional UDMA 300x CF Cards
29. Giotto Rocket Air Blower

Flash Accessories
30. Nikon SC-29 TTL Coiled Remote Cord
31. Lumiquest 80-20
32. Color Correction Gels (Lee and Rosco brands)

Computer and Accessories
33. Apple 15" MacBook Pro
34. Extra Rechargeable MBP Batteries
35. Lexar Professional UDMA Firewire 800 Reader
36. Belkin Pro Series Hi-Speed USB 2.0 cable w/extender (for tethered shooting)
37. 160-GB iPod Classic
38. Bose QuietComfort 3 Acoustic Noise-Cancelling Headphones
39. JBL Portable Laptop Speakers
40. Verizon Wireless BroadbandAccess National Access Card

"Bose noise cancelling earphones. I spend a LOT of time on airplanes."

Various Accessories
41. Sharpies
42. Leatherman Wave tool
43. Petzl Headlamp
44. Sources of entertainment/imagination/inspiration such as *Blazing Saddles, This Is Spinal Tap, Shaun of the Dead, Young Frankenstein, Super Troopers, Monty Python and the Holy Grail, Office Space, Hot Fuzz*, etc.

© Brad Moore

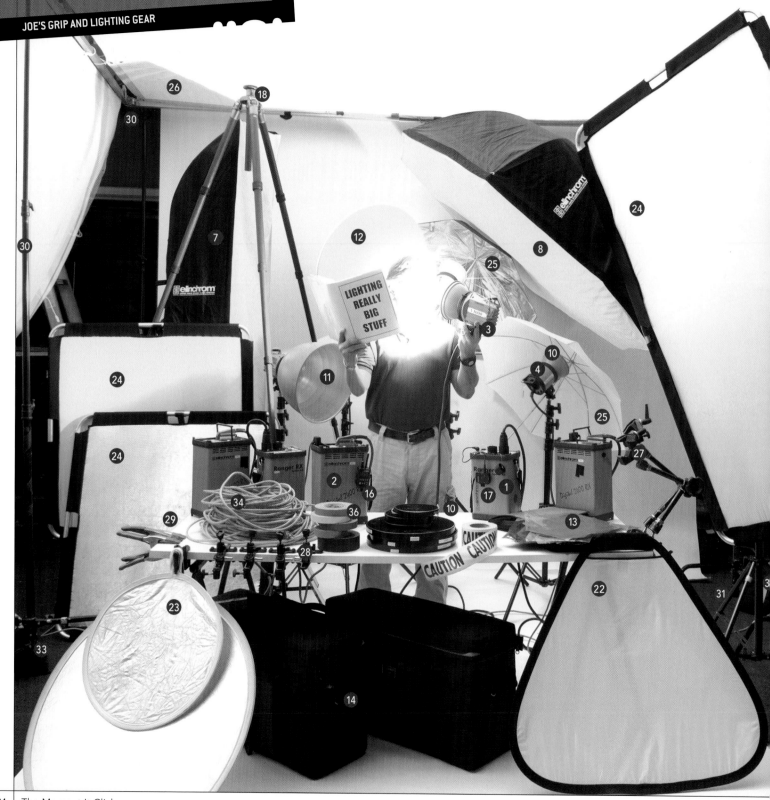

LIGHTING
REALLY
BIG
STUFF

Photo © Brad Moore

Joe's Grip and Lighting Gear

1. Elinchrom Ranger RX Speed AS Battery Packs
2. Elinchrom Digital RX 2400 Power Packs
3. Elinchrom A 3000 N Speed Heads
4. Elinchrom Free Lite A Speed Heads
5. Elinchrom Ring Flash 3000 (not pictured)
6. Elinchrom Ranger RX Ringflash 1500 (not pictured)
7. Elinchrom EL Strip 33x175 cm
8. Elinchrom EL Octa 190 cm
9. Elinchrom Standard Reflector 21 cm 50° w/grid set (not pictured)
10. Elinchrom Standard Reflector 18 cm 60° w/grid set
11. Elinchrom High Performance Reflector 26 cm 48°
12. Elinchrom Softlite Reflector 44 cm 80° white w/Deflector Set
13. Rosco and Lee Color Correction Gels
14. Lightware T4444 Strobe Head Cases
15. Lightware H7020 Large Head Pouch (not pictured)
16. PocketWizards MultiMAX Transceiver
17. Elinchrom EL-Skyport Universal Trigger Set
18. Gitzo GT-5560SGT Tripod w/Center Column
19. Manfrotto 468MG Hydrostatic Ball Head (not pictured)
20. Manfrotto Accessory Arm 3153B (not pictured)
21. Gitzo G065 Monitor and Laptop Platform (not pictured)
22. Lastolite Tri-Grips
23. Lastolite Reflectors
24. Lastolite Skylite Kits (various sizes)
25. Lastolite Umbrellas (various)
26. Avenger 12x12' Butterfly Foldaway Frame w/12x12' Silk
27. Manfrotto 244N Variable Friction Arms w/Super Clamps
28. Manfrotto 175F Justin Clamps
29. A-Clamps
30. Avenger C-Stands with 40" Extension Arms and 6" Pins
31. Avenger A635B Maxi Kit Stands
32. Avenger Mini Booms (not pictured)
33. Avenger Sand Bags
34. Heavy Duty Stinger Extension Cords
35. Power Strips (not pictured)
36. Gaffer Tape

"Tri-grips...handy to fan your subject with. Makes 'em feel good."

The Bar Is Open

Let's call it Louie's East, in honor of that semi-famous dive that used to be on the corner of 41st and 2nd Avenue and served as the unofficial watering hole, hideaway, strike war room, and confessional of the New York *Daily News*. Often, as a copyboy, I would be dispatched to the third floor, where in the din of presses that at the time jackhammered out over a million papers a night, I would pick up a few dozen one-stars, the Bulldog, the first edition of tomorrow's paper.

Next stop, Louie's East. I would not return to the seventh floor newsroom. I would go downstairs, cross the street, and walk through the doors and into a solid wall of stale beer smell. I would then walk along the bar and distribute papers, and editors would phone in their corrections over a boilermaker or two.

I'm not disparaging the place unfairly. It actually reveled in how scruffy it was. There was graffiti in the men's toilet that read, "Don't do no good to stand on the seat…the crabs in here jump 10 feet." I shit you not, to continue the visual.

It was part of the mix, the culture of New York journalism. Here would mix poets and scribes and columnists and editors and photographers, all reveling together in the imperfect and wonderful occupation of telling stories. It was here I think I first heard that old wink-wink tabloid mantra: "Some facts are too good to check…."

Tales got told. Here are a few…

"I had one clean, dry 50mm lens in my pocket. I rewired that camera, popped the lens on, and patted it for luck."

A bad day in the field beats a good day at the office, anytime. There are days that test this proposition. I once destroyed five motor-driven Nikons in one day. *That* was a bad day in the field.

When shooting a space shuttle launch, you are relying mostly on cameras you can't be with or near. They're called remotes, and you put them in the field 24 hours in advance of liftoff, rigged with devices that will trigger them (hopefully) at the right time. At launch time, you're miles away, shooting a 1000mm lens through the heat waves. Lots of luck with that.

I put nine cameras in the field—the field being the saltwater estuary surrounding the launching pads at Cape Kennedy. I had high hopes.

A storm hit before liftoff. One of the worst I'd ever seen. All the photographers begged NASA to go back out and see what was left of their stuff. It was a camera graveyard out there. Grown men were crying. In my case, the only evidence of one of my rigs was three inches of tripod leg sticking out of the flooded swamp. I waded in up to my neck, eyeballing alligator warning signs, trying to haul my gear up from the muck.

Seeing as I was already in the swamp, I tried to get out some of the other shooters' gear as well. They were standing on the bank, giving me directions. Since they were from the South, I asked if any of them knew whether a big storm got the gators riled up and made them more active. An answer came back: "Don't you worry. Y'all just go get our stuff." Probably the best use they'd ever seen for a Yankee.

My last rig was damaged, but not destroyed. I had one clean, dry 50mm lens in my pocket. I rewired that camera, popped the lens on, and patted it for luck. It was still pouring, and I figured I was just SOL. Turns out, the camera fired. Got a picture that ran as the cover of the year in a science issue for *Discover*, and it saved my butt.

The hard part was still to come. I had to call Al Schneider, cigar-chomping manager of the Time Life photo equipment area, to tell him I just destroyed a good chunk of the company's pool photo gear. The cameras were in a garbage can in my shower at the Days Inn, being flushed with fresh water, when I called. Al chuckled. "I got the perfect solution for ya, kid," he said. My heart skipped a hopeful beat. "Yeah," he went on. "Deeper water."

"Gosh, you mean after I get approved by a bunch of 20-year-olds, and I shoot it for free, I might get to use it after six months?

Where do I sign up?"

My studio manager got this not too long ago from a magazine:

"Thanks very much for your email. It looks like before confirming this, both of our ends have to check on remaining details, i.e., our whole creative team has to agree on contracting Joe. Additionally, while we are happy to take care of the production legwork—i.e., getting the talent, clothes, makeup and styling, location scouted, and permission acquired—we generally do not offer a fee for photography. Unfortunately, with the increase of our circulation came staggering print cost increases. It is a large shot (virtually a full page), however, and a dynamic image. I will also get back to you ASAP with regard to usage, but I imagine that he will be able to publish it wherever he likes after 6 mos. time."

Gosh, you mean after I get approved by a bunch of 20-year-olds, and I shoot it for free, I might get to use it after six months?

Where do I sign up?

One of the new road signs to Freelanceville.

I was shooting a *Time* cover on the launch of Disney's Animal Kingdom. Disney being Disney, they jumped into the zoo business with both feet, scouring zoos everywhere and buying up bunches of animals.

It was a cover story, so there was a lot of pressure. I needed certain things to happen which weren't happening.

The main attraction was the safari ride, which I was told I had to shoot from the safari vehicles on the established path of the ride. No exceptions. I told them this was impossible. How do you shoot a picture of something you're sitting on?

I also wanted to shoot behind the scenes with the animals, to show how they were being cared for. Disney didn't want to show the animals behind bars. They wanted the public to believe that at night,

the animals were being cared for by Mickey and Tinker Bell, and instead of being caged, they were chatting amongst themselves and hanging around at Pleasure Island.

They told me behind-the-scenes photos were impossible.

I knew I had to go to the top. Michael Eisner and I go way back. I've put him in a tree. I've shot him with Roger Rabbit. We've also done some male bonding in an 80-foot bucket crane over Disney-MGM Studios. He's actually okay to photograph and knows the value of a picture.

Time's writer was interviewing Eisner over lunch at Animal Kingdom. Being the photographer on the story, I knew I wasn't invited. The only way I'd get close to the table was to put on a waiter's uniform. I hung out at

the bar, biding my time. The writer had promised me he'd take my case to Eisner. Right.

The lunch broke. I made my move, cutting Eisner off in between the tables, giving him nowhere to go.

He rolled his eyes. "What do *you* want?" was the first thing out of his mouth. "I need to get off the safari path, and I need to get behind the scenes with the animals." You have to hit it hard and fast. He also knew I was a persistent pain in the a$$, which worked in my favor.

"Okay for the safari and behind the scenes if it's just for *Time*." He looked around and his people all nodded. Done.

Both pictures ran. Photographers… we're pests. But we know what we know.

"Be a PEST!
They told me behind-the-scenes photos were impossible."

"Then he beamed and clapped me on the shoulder. 'You could be management!'"

Never live with a fashion model.

I did. What can I say? The guys at the *Daily News* loved her, and were always asking for updates about my love life. Particularly Caruso, who was one of those Italian guys from Brooklyn who just adored women.

But we broke up. Badly. Had to throw her out. In December. I moped into the *News*. Caruso saw me. "Hey howzitgoin'? How's the girlfriend?" I shook my head. "Not too good," I said. "I hadda throw her out. She's gone."

His eyes widened. He grabbed me and threw me back against the wall. He had a wild look on his face. "You trew her out?!" he screamed in his best Brooklynese. "In the deada winta? Right before da holidays? You heartless bastard!"

Then he beamed and clapped me on the shoulder. "You could be management!"

"I was always very careful when processing his film, 'cause the outline of a huge handgun was always plainly visible under his sweater."

Back in the '70s in New York, dead people turned up regularly. Subway platforms, street corners, parks—you name it. You just stepped over them on the way to work.

Naturally, the *Daily News* had a crime photog who worked the overnight shift. Big guy, made bigger by the cowboy hat he often wore and the bulky sweaters he usually had on, even in the summer.

I was always very careful when processing his film, 'cause the outline of a huge handgun was always plainly visible under his sweater.

Not that it was ever complicated. He shot 20-exposure rolls of Tri-X[1], and there were usually three frames: one out-of-focus frame of the trunk of his car (as he retrieved his gear and loaded his film), another out-of-focus frame of his feet as he walked over to the scene of the crime, and a reasonably sharp shot of the dead body.

That was it. Short and sweet. I always told him I liked his work.

[1] Tri-X—Kodak Tri-X is the legendary black-and-white film for the ages, staple for many years of photojournalists everywhere.

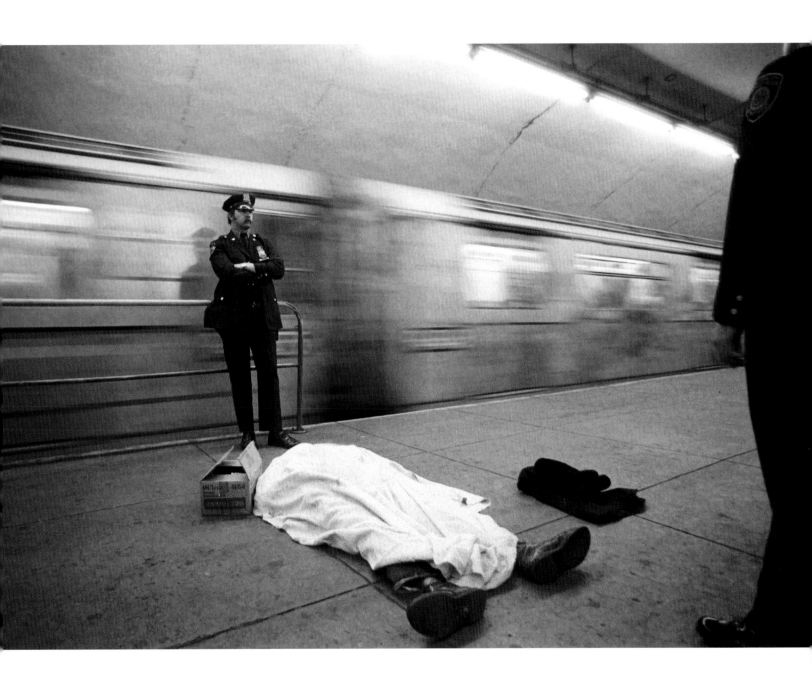

How about kissing a moose? Well, maybe just kiss the baby.

It was my second story for *Life*. I was excited, but still terrified I would screw up and spend the rest of my career shooting for *Compressed Air Monthly*.

The story was on nannies, a newsworthy item back in those days. John Loengard, picture editor and provocateur, called me in to discuss ideas. To John, a nanny was Mary Poppins, complete with pram and starchy uniform. I was shooting the story out west and the visual changeup had John's juices flowing.

"How about all the proper nannies and their babies out in the Rocky Mountains?" he suggested. "Or maybe one (in uniform) with her pram walking through a dusty cowboy town?" None of that was going to happen, but that didn't matter to John.

He paused. "Maybe if you had a nanny kissing a moose. I'm just thinking out loud, Joe."

I, of course, nodded and staggered out of his office. Mel Scott, the deputy picture editor, saw me with my eyeballs rolling around. He knew what'd happened.

He motioned to come into his office and closed the door. "Okay Joe, what you gotta do now is put all that stuff out of your head and just go make a picture. Ya hear me?" He had this great Texas accent. "Just go make a picture."

John and Mel were the best good cop/bad cop act in all of photography. John would get you to think (and occasionally scare the bejeezus out of you), and Mel would calm you down and tell you everything was gonna be all right.

As photographers, as an industry, we sorely miss both of them.

"Maybe if you had a nanny kissing a moose. I'm just thinking out loud, Joe."

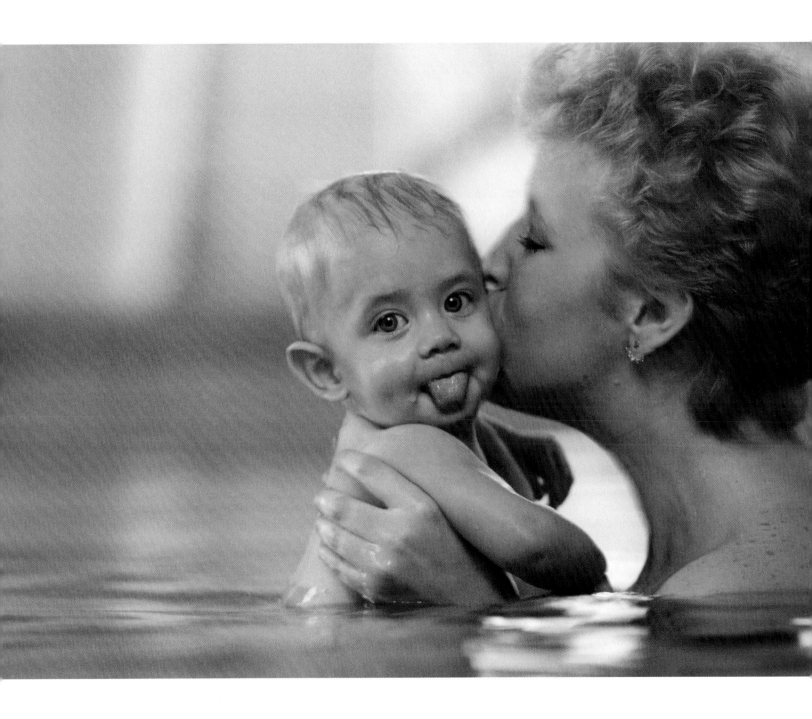

It was a picture of a famously huge argument and I got it because I lied. A real New York story.

The person I lied to was Larry DeSantis, the legendary UPI pictures editor, a giant, bespectacled bear of a man who was anything but cuddly. You loved him, you hated him, and at all times, you feared him.

I came to Larry's attention in 1978, while I was participating in what was at that time a rite of passage in the New York newspaper industry, a strike. While the pen may be mightier than the sword, in the New York press game, the truck is mightier than the sword, the pen, and the camera put together. The pressmen had gone on strike, the drivers sided with them, and that was that. Management could write the paper, shoot the paper, and even print the paper, but what was the point if you couldn't deliver it?

The *Daily News* shut down for 88 days and, though I was still just a copy boy, I started shooting pictures for UPI. I was right up their alley in terms of employment: a warm body with a camera who was willing to work cheap. One day in the office, Larry looked at me and croaked, "You ever shoot baseball?" Enter the lie. "Oh, yeah," I gushed. "Syracuse (my college town) had a semi-pro team. I shot baseball all the time." As was his way, Larry grabbed me by my belt and pulled me toward his desk. Still holding my belt, Larry took a Yankees credential and stuffed it into my crotch. "Third base," was all he said.

I floated down the hallways toward the elevators. I was just a copy boy at the *News*, and here I had the UPI third base credential for the Yankees-KC playoffs in my underwear! Then it hit me. I had never shot a baseball game before in my life.

As a photographer, when asked such questions by an editor, you should always say yes, even if the assignment terrifies you. (Actually, especially if it terrifies you.) That is not to say such adventurism doesn't produce qualms and difficulties. In those days of wet darkrooms, when some technician was working like a stevedore in a closet-sized room in the bowels of an athletic stadium, and the film was getting ripped out of the hypo, sloshed in some water, louped, and printed while still wet, you obviously

"Feeling pretty good, huh, kid? That's an attaboy, a good job...just remember," he said, "It only takes one 'aw, shit' to wipe out three 'attaboys'."

didn't overshoot and send roll upon roll back to the beleaguered processing operation. During a big playoff game, you'd shoot everything, but you didn't ship everything.

I was so terrified in my first games that I shot like mad, and shipped like mad. At the end of one dismal effort on my part, Larry motioned me over, in disgust. If you'd put a nun's habit on him, I would've felt like I was in third grade again.

"Tonight," he said, "You set the world's record for shipping me INSIGNIFICANT film. Ground balls. Pop ups. What's this garbage? @!!%$#$!"

He concluded with a brief analysis of my ancestry and a quick overview of his rather dim hopes for my future in the business.

This was all done quite publicly. I felt like my pants had been taken down in front of the entire N.Y. press corps, many of whom were enjoying the rookie's embarrassment.

The next night, I got this picture, which became one of the most widely published of the playoffs. I watched it spin on the wire machine after the game, feeling redemption with every beep of the transmission. Larry walked up to me. "Feeling pretty good, huh, kid?" he asked. Nodding with affirmation, he continued, "That's an attaboy, a good job." An enormous forefinger waved slowly in front of my face. "Just remember," he said, "It only takes one 'aw, shit' to wipe out three 'attaboys.'"

Career advice for the freelancer.

Lou Piniella & Ron Luciano

"Then I start thinking...Beauty and the Beast!
They're, you know, like, in LOVE!
My mind starts racing.
They're gonna go upstairs and do it!"

It helps to be a bit of a romantic sometimes. I was shooting the *A Day in the Life of Hollywood* book and one of my stops was to make pictures of Alan Menken getting a BMI music award for *Beauty and the Beast* at the Regent Beverly Wilshire Hotel.

For a photographer, an award ceremony is a non-starter. Uhh, lessee…should I cover the award ceremony, or should I go get that long overdue root canal? Hmmm….

Anyway, Menken wins the award, and the photogs close in and go disco, shooting flash so motor-driven fast they must have had Honda generators strapped to their belts. I'm in the mix, doing the same thing, thinking, man, the movie might be a hit, but this picture I'm getting closes out of town.

The furor calms down, and Beauty and the Beast walk away. I walk away, too, but then I start thinking…Beauty and the Beast! They're, you know, like, in love! My mind starts racing. They're gonna go upstairs and do it! The Beast must have an enormous schvenstalker! They're heading for the elevators!

Luckily, the Bev Wilshire hotel has a sweeping staircase with two sets of steps. Beauty and the Beast lumber up one, and I sprint up the other. They get to the elevator bank and…there's Joe!

I got a frame that was a double truck[1] in the book.

[1] Double Truck: A double truck is a two-page spread.

First time I ever saw Eddie being Eddie was at the 1980 Democratic National Convention. Eddie is Eddie Adams, of course—shooter, legend, raconteur, hero, rock star, sage, keeper of the "Shit List," friend, mentor, and (occasionally) irascible old coot.

I didn't know him back then. I was a newbie, and he was Eddie. He seemed pretty gruff. I was scared of him.

But I did notice him going around with this galoot of an assistant who obviously didn't know anything about photography. Curious. The guy was big enough to play linebacker for the Chicago Bears, and in fact, probably did, but a photog he wasn't. But the guy was big. Real big.

So the last night of the convention, President Carter, ever the populist, decides to walk through the convention floor to the podium instead of using the back hallways like the elitist sumbitches most politicians are, and it drove the Secret Service nuts. Tension was high. People were jammin', trying to get a piece of the man from Plains, and security was determined not to let that happen.

What did happen was about a 100-yard free-for-all scrum across the length of the convention floor. Cops and G-men formed a flying wedge and drove forward, trampling all in their path. Conventioneers pushed back and mayhem ensued. I tried to get a picture by standing on a collapsible chair. Bad move. I went down, hard. Got nothing.

My one memory as I fell was Eddie Adams wading through the crowd like Moses with a Leica, astride the shoulders of his linebacker assistant, who was making short work of the respectable delegates from the great states of Alabama, Connecticut, and Rhode Island by simply picking them up and tossing them aside.

I was lying on the floor with the skid marks of peoples' shoes all over me and my gear and thought, "Son of a b!&¢# knows what he's doin!"

"My one memory as I fell was Eddie Adams wading through the crowd like Moses with a Leica, astride the shoulders of his linebacker assistant...."

President Carter

"Not everybody's gonna think your stuff is the greatest thing since sliced bread.

Put a picture out there, and anybody who sees it can say anything they want about it. It isn't the business for a thin skin."

At the *Daily News*, we used to edit by projecting the negs on screens. It was a brilliant way to edit B&W, 'cause reading the neg instead of the contact sheet would give far better info about sharpness and quality. Editors like Phil "Stanzi" Stanziola were terrific at essentially reading in reverse…the negative instead of the positive.

When your stuff was on the screen, of course, the standard comment from passers-by would always be something like, "Whose $#!% is this?" It would go downhill from there, especially if something was, you know, soft. (I'll leave that range of commentary to your imagination.)

Some folks are gonna love your stuff and some are gonna hate it. Some editors will adore you as a shooter, and others wouldn't assign you to an "Editor's Note" job.

I've always taken solace in the philosophy of good ol' Miss Lillian, Jimmy Carter's mom. Campaigning for her son, she was brought up short by an earnest young gentleman who shared that he liked her a lot, but he wasn't going to vote for her son.

She just laughed and patted him on the cheek. "That's okay son, we didn't expect it to be unanimous."

Miss Lillian Carter

Never underestimate terror as a motivational tool.

National Geographic sent me to Hawaii to come up with an unusual picture of the Ironman Triathlon.

I was psyched. An underwater view of the Ironman! I did the whole thing—Zodiac boat, underwater camera rigs, permissions, you name it. I was ready.

Morning of the race. I'm in position (40 feet below the surface) waiting for the start. A few swimmers go overhead. Then a couple. Then nobody.

Ever get that sick feeling in your gut, the one that lets you know you really screwed the pooch? I had drifted on my dive. The swimmers went wide of me.

I surface and throw myself into the Zodiac boat and race to the first turn hoping the swimmers would gang up again. I'm trying to reload my cameras and regrease the O-rings as I'm being tossed around in the boat, slammin' through the waves. No luck at the turn. So we haul a$$ to get to the finish before them. I throw myself into the water again.

It gets worse. As soon as I hit the water, one of my strobes goes disco, a sure sign of a flooded rig. I drop it on the bottom. I see the swimmers starting to funnel down into the finish and I get a camera ready.

And then my regulator starts getting pulled out of my mouth. I look up, and my air tank had slipped its cinch (my bad) and was wanting to scream to the surface, my air supply with it.

I reach up, grab the tank, and tuck it under my left arm. With my right hand, I got a camera to my mask, and squeezed two frames of the bunched swimmers. They never grouped up again like this. I was done for the day.

I mean, how was I gonna call my editor and explain that I just freakin' missed 2,500 relatively slow-moving people?

"Never underestimate terror as a motivational tool. I mean, how was I gonna call my editor and explain that I just freakin' missed 2,500 relatively slow-moving people?"

"She reached over with her little hand
and patted me on the shoulder and said,
"Don't worry, Daddy, just do the best you can.""

Occasionally I am asked about how to balance the life of a photog with, well, life. In response, I have described my three roles of husband, father, and photographer as three people drowning at once. There is a lot of grabbing, splashing, and flailing about, no one is on the surface for very long, and generally none of the three of us are doing particularly well.

Sometimes you try to be a good dad and it means you're a bad photographer—you go into the field with no sleep, no prep, and without an idea in your head. The converse is often true. Prepare, get obsessive, dwell on the job, go out there and knock it back and bask in the reverb of a good frame, dream about the phone ringing from JLo's agent for the cover of her next CD, and…what were my kids' names again?

I used to even screw up bedtime stories, I was so exhausted most of the time. Caitlin (my 22-year-old daughter) regularly busts me about this now. She even remembers the night I returned from a job in Chicago and tried to tell her the story of the three little pigs. Somehow, what came out of my mouth was, "And all the ships were made of bricks, and it was a good night to Chicago." No joke. That twist on the old fable stuck in her head, and she trots it out now and then to embarrass me.

We were snuggled one night, and I looked at her and said, "You know, sweetie, daddy's so tired tonight, I don't think I can even get through one story." She was about two. She reached over with her little hand and patted me on the shoulder and said, "Don't worry, daddy, just do the best you can."

Claire and Caity

"Always ask the tough question. It's a long plane flight home if you don't.

And the more sensitive the question, the more it needs to be asked, and very directly. I'm not saying to be harsh, just direct."

One of the privileges of my career has been to meet Kim Phuc, a.k.a. The Napalm Girl. Horribly burned at the age of nine in Vietnam, she crusades now for peace.

I was sent to find people who had been the subject of Pulitzer Prize–winning photos. When you're the subject of a Pulitzer, it is generally not by choice, because by and large, they're not happy moments.

So it was with Kim. She's alive because AP shooter Nick Ut took the picture. Then he dropped his cameras and got her to a hospital. But because of the photo, her life became a bizarre, propaganda-driven odyssey. If I ever think pictures aren't important, and I get tired, frustrated, and down, I think about Kim. Her whole life has spun on a photograph, a slice of a second.

Returning from a Moscow honeymoon, she and her husband applied for asylum in Canada, so I went to meet her in Toronto. We talked. I told her I needed to see her scars. Otherwise, there was no point to my being there. She understood.

Luckily, she was breast-feeding Thomas, her new baby, which gave us the perfect way to show how this beautiful dumpling of a baby sprang from her scarred and battered body. It is a hopeful picture, appropriate for Kim.

Kim Phuc

You always know when you've got the frame. I mean the one you come for. Sometimes something we thought sucked actually works out, and sometimes the client hates what we thought was pretty good. But now I'm talking about *those* frames—the ones that stick. They only come along every once in a while, but when you get one, you know it.

You may know it by a skip of your heart, a short gasp, a split-second of vertigo in your brain, or a feeling like you've just gotten a quick punch to the gut.

Or, you may feel it elsewhere. One of the old-timers at the *Daily News* once looked at me and made a little circle with the tips of his fingers and his thumb, which he then started squeezing and releasing in rhythmic fashion. "You always know when you're gettin' good stuff, kid, 'cause you can feel your @$$hole goin' like dis." He continued squeezing until he was sure I got the point.

I once related this story to a class of military photojournalists, who immediately classified this as "the pucker factor."

"You always know when you've got THE frame. You may know it by a skip of your heart, a short gasp, a split-second of vertigo in your brain, or a feeling like you've just gotten a quick punch to the gut."

"With the windowless plane dipsy-doodling, and people standing on the ceiling, and me looking through a lens, I realized why the plane's nickname was the 'vomit comet.'"

Bring money! When it comes to getting something done in the field, pronto, there is nothing like cold, hard cash. This is very true in Russia. It's painfully true when it comes to the Russian space program. U.S. greenbacks are the fuel in the boosters.

I went to shoot a story for *Life* in Star City, the cosmonaut training center. We had a deal with the Russians. They reneged. Greetings, comrade! We have lied to you repeatedly!

I got onto this plane and got this frame by stuffing $7,500 into the hands of my Russian contact at Star City on a runway in an ice storm. He jammed the wad in his pocket, turned to the pilots, and gave the signal. They spun the props and rolled down the runway.

The zero-G plane flies parabolas—a series of steep dives followed by rapid ascents. At the top of the curve, just before the plane dives again, you go weightless for about 30 seconds. As one American astronaut told me, it's the most fun you can have with your clothes on. Maybe so. But with the windowless plane dipsy-doodling, and people standing on the ceiling, and me looking through a lens, I realized why the plane's nickname was the "vomit comet."

I retched at least 50 or more times. After a while I forgot about the bag and just horked up what was left of my stomach inside my flight suit. I was a sweaty, stinking mess. The Russian doc got so worried he started massaging my ears during the dives so I wouldn't pass out.

Astronaut Mike Lopez-Allegria held my feet to stabilize me while he was anchored to the floor with a bungee cord. I floated up and made fill flash pictures on Kodachrome. I just kept cleaning out the eyepiece to my camera and hammering frames.

When we landed, I was standing with a bunch of astronauts on the ground, and my stomach dry heaved again. Heard chuckles all around. "Somebody wanna tell Joe here the flight's over?"

"I wept for her, for me, but mostly because the siren call of my first big story with a yellow border around it was more powerful than the call of fatherhood."

There needs to be a course in school about how to be a parent and a photographer. Not that we'd listen. All of that is so far away.

I missed a whole bunch of my kids' growing up. Every traveling shooter does. I have a memory of a day when I was leaving for a four-week trip to Africa for *National Geographic*. My daughter Caitlin and I were in the driveway. It was hot and the sun was harsh. She was about three years old and had watched the familiar ritual of Dad loading the taxi to go to the airport many times.

I hugged her hard. Told her the usual things. She didn't understand or care about what I was saying. I knew that. The things we say in these moments to our kids make us feel better, not them.

The cab pulled out and I twisted around and looked back, desperately waving. She couldn't see me. The light was too bright. She waved once, and left her arm pressed against her forehead, shielding her eyes. The sun was glaring through the dirty window, and she faded from view, hot and yellowish, like an old Polaroid from the '50s.

I slid down in the seat and began to weep. I wept for her, for me, but mostly because the siren call of my first big story with a yellow border around it was more powerful than the call of fatherhood.

"The man was working at a feverish pitch.
This was his pope, his moment, his country.
He was making pictures he would tell his grandchildren about."

The first papal trip to Poland was tough. The government was still Communist, Solidarity was getting feisty, and John Paul's visit was fuel for that fire. The government put the squeeze on the press, hard.

They would, for instance, make it almost impossible to cover the pope, dropping us miles from the site of the mass, and erecting photo platforms so far from the altar you thought you were shooting a shuttle launch.

This went on for two weeks, a constant battering. I was at one mass in the countryside, and I had all the glass in my bag stacked on my camera, which meant a 400mm lens with a TC 1.4 converter with a doubler on top of that, and through all that the pope was still the size of a pea. To make matters worse, I was shooting in a driving rainstorm.

To add insult to injury, I was shooting for *Newsweek*, which meant I wasn't connected. *Time* had the inside track, because *Time* had a contract photographer based in Rome. His main strengths were not photographic. He knew how to work the Vatican. He had the place wired.

I'm out there with no picture to make, so just for grins I sweep the altar, poking around. And there, not more than 50 feet from the pope, is the

Time guy. The kicker was not just his proximity, but the fact that there was a cardinal holding an umbrella over him while he shot.

My mood turned black. I became aware of another shooter, who had wedged in next to me, when the railing we were using for camera support started shaking. This guy was huffing and puffing, shooting like mad, and the whole platform was quivering. I turned, ready to tear somebody a new one, and stopped.

He had like a Novosiberskoflex, or some East bloc camera with a preset lens about half the focal length of my rig. It was a single-shot camera, wired with a cable release he had taped to the lens barrel. He had no right hand. He would focus left-handed, and steady the camera with his stump, then squeeze the cable with his good hand. Then he would reverse the grip and advance the shutter with his stump. The rail was shaking because of all this maneuvering.

The man was working at a feverish pitch. This was his pope, his moment, his country. He was making pictures he would tell his grandchildren about. I stood there, with a camera store around my neck, on assignment for a major international publication, and I had peevishly stopped working.

I felt ashamed. I put my eye back in the camera.

Listen to your assistant. They can save your butt.

The baseball editor at *Sports Illustrated* looked at me and said, "I hate the baseball pictures. Go to Florida and make them look different."

Turn the page and I'm at spring training, bombing around with a movie grip truck, an 18-wheeler, lighting up the Citrus League, doing simulated action pictures of the defensive stars of baseball. We shot them at dusk, after the games, and had to draw so much electric that we needed a truck with a 600-amp generator so we could fire the 10 to 15 2,400-watt-second Speedotrons we were routinely using.

Shot Eric Davis of the Reds, star outfielder, stellar defender, specialist at the leap-at-the-wall-rob-your-ass-of-a-home-run move. Which is exactly what we set up.

We lit up the outfield, got Eric out there, tossed a ball up to the wall, and he'd leap spectacularly and grab it. You're out!

"Listen to your assistant. They can save your butt."

I was shooting a Mamiya RZ with a 50mm lens, on a sandbag lying on the grass. Things were going great. I had about 10 frames of Superman-type leaps. Small problem—they were all on one piece of film.

The Mamiya has this clutch button that if it's depressed, you can fire the camera but not advance the film. Ideal for multiple exposures, if that's what you're in the mood to shoot.

My assistant on the job, Howard Simmons, who has gone on to a terrific career as a staffer at the *Daily News*, was roaming, as all good assistants do. He bent over to check the camera I was shooting. I heard a gasp. He whispered in my ear, "We have shot no film." He left out the "dumb$#!%" part, which I appreciated.

Whaddaya do? Eric was ready to leave. He was huffing and puffing. "Uh, hey, Eric, those looked sooooooo fantastic that I need to get just a few more on another roll of film. You know, just in case we lose the one we just shot."

Or in case some idiot behind the camera made art when he should've been making pictures.

Eric Davis

Sometimes the camera has to do all the work. You may have to do a lot of work to get that camera into the right spot, but then you just have to sit back and hope it all goes okay.

I worked for about three weeks to get this camera attached to the frame of a T-38 during a flight with Senator John Glenn in the back seat. Anything that gets attached to a tactical aircraft has to go up, down, and sideways through an approval process.

Then, when you get the approval, ya gotta figure out a way to make it stay put while the flyboys are up there rockin' and rollin'.

It would not have been a good day in the field if this camera had gotten loose in the cockpit.

The NASA engineers were great about it, devising plates and bolts to get it tucked away safely. This particular shot was with a Nikon N90 and a 16mm fisheye.

Senator Glenn and I shared a credit in the magazine on this, which was a cool thing. I told him, "John, just squeeze the button (on a remote cord run to his fingers) and look toward the light." He did it perfectly.

Working with the Senator was one of the honors of my career. He was great about being photographed. I always teased him that he had gone to the Ralph Morse School of Being a Photo Subject.

"Sometimes the camera has to do all the work. You may have to do a lot of work to get that camera into the right spot, but then you just have to sit back and hope it all goes right."

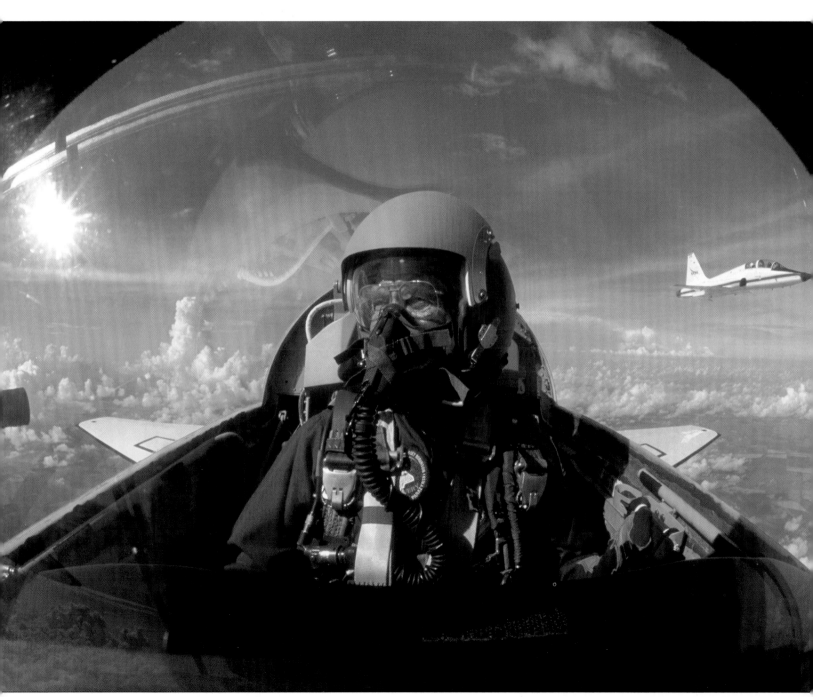

John Glenn

When I got offered three weeks of day rates to shoot the first launch of the space shuttle, I walked into my job at ABC television and quit. I promptly converted those day rates to a plane ticket to Northern Ireland. It was 1981 and the hunger strikers in the H blocks were about to die. The place was gonna blow.

I went over with my bud Johnny Roca, a *Daily News* shooter. He was great companionship. We'd be in the middle of a riot, rocks and bottles everywhere, rubber bullets flying, and he'd nudge me, "Joe, you can't believe the blond in the upstairs window across the street."

It was back in the day when ABC had a trio of anchors: Frank Reynolds in Washington, Max Robinson in Chicago, and Peter Jennings in London. They only moved these guys out from behind the desk for a really big story. Sure enough, they moved Jennings to Belfast. My old boss at ABC got word to me to try to get a photo of Jennings. A day rate is a powerful motivational tool when you're broke, so I promptly looked him up.

He was cool with it. I ended up photographing him numerous times during his career. He was a good newsman, and always decent to work with and easy to make a picture of. He said to me in Belfast, "So what they want here, Joe, is the trenchcoated anchorman on the streets of the war-torn city, right?" I nodded.

The North calmed down and I headed for London. ABC contacted me again. Shoot Jennings at the bureau. I walked in, and five minutes later, the wires started clacking furiously. The pope had been shot.

"Jennings told me I could come with him to Rome. I called my agency in N.Y. They were screaming, 'Go, go!'"

Jennings told me I could come with him to Rome. I called my agency in New York. They were screaming, "Go, go!"

I arrived in Rome in the wee hours aboard a private jet with Jennings, his producer, and myself. Peter checked me into the Cavalieri Hilton, one of the nicest hotels in the city. I had a maxed out credit card and about 10 bucks in my pocket. My agency wired me money the next day. I spent the next two weeks in Rome on assignment for *Newsweek* and *Bunte* magazines, the same magazines that had picked me up in Ireland.

I went broke and without prospects, and came back with a freelance career started. As fellow shooter Keith Carter is fond of saying, this is the type of business where you have to make uncertainty your friend.

"This is the type of business where you have to make uncertainty your friend."

You don't have to go to Afghanistan to shoot good photos. The most important pictures you will shoot are right there in front of you, of the people and places closest to you.

My kids and I were at Walt Disney World, at the hotel pool. Claire, about eight at the time, decided to be a torpedo and pushed off the bottom in the nine-foot-deep section to zoom to the surface. Thing is, she zoomed at an angle, not a straight line, and her face crashed full speed into the wall of the pool. Ouch.

After we got everything calmed down and figured out no permanent damage had been done, I pulled out a Coolpix to JPEG a damage report to her mom. (This was my first vacation as a divorced dad with just me and the kids. Figures.)

The result was one of my favorite pictures. At a tough, painful moment in her young life, Claire looks back at the camera undaunted and unbowed (you lookin' at me?). Her eyes are deep pools of resolve. I suspected then, as I do now, that Claire will live life on her own terms, and won't take much grief from anyone. (Uh, this would include her dad.)

Lovely, intimate bits and pieces like this are the glue that hold together the scattershot life of a photog. In my helter-skelter pursuit of "big" pictures, I ignored too many quieter, close-to-home moments. As I look back, I wish I had more of 'em. Especially now, 'cause my kids won't put up with me pointing a camera at them anymore.

"In my helter-skelter pursuit of big pictures, I ignored too many quieter, close-to-home moments. As I look back, I wish I had more of 'em."

Claire

"Like I said, there ain't nobody like him."

Face it, Walter Iooss is the coolest photographer walking. I mean, he's just Walter, man, and there ain't no other.

I was assigned to shoot the 1980 U.S. Open Golf Championship out in New Jersey. I had never shot a golf match before in my life. I had no idea what I was doing.

But Walter Iooss did. So I stuck with Wally all day. Looking back, I was kind of blatant about it, but he didn't seem to mind. I was a pup, and he was, you know, Walter, even back then. He had an assistant who carried only one camera, I think, with a 600mm lens. Walter would stride down the fairway unencumbered.

I was carrying all my stuff: a six, a four, a three, all with motors, wide glass, camera bag, strobe. It was tough keeping up, I tell ya. Walter takes one step to every four of mine.

We come to the last hole. Iooss gets a spot, and I'm right next to him. Nicklaus holes out and wins the tournament, and goes jubo right there. I get the only good golf frame I've ever shot.

Like I said, there ain't nobody like him.

Jack Nicklaus

"She said, 'It's for luck, Daddy.'"

I was in the basement preparing to go off somewhere, as usual, and I was doing the checklist thing. You know: cameras, lenses, batteries, film, chargers, cords, bunny head….

Bunny head?

My daughter Caitlin was about three at the time, so I brought it upstairs and asked her about it. She said, "It's for luck, Daddy."

It's much bedraggled now—it's lost its eyes and mouth, and it could use a run through the washing machine. But it's stayed in my camera bag through wind and rain, bad locations, Godforsaken places, dicey jobs, big jobs, small jobs, bad jobs, you name it.

Caitlin just turned 22.

"All the while I was sitting at the clink, waiting for news, these guys were home having wine and a nap, waiting for a call from their guy at the jail."

Know who you're talking to. Photo director and editor Rich Clarkson is fond of saying that, and you know, he's right.

I was in Rome, young and single, on assignment for two weeks, waiting to see if the Pope was gonna die.

I would go to the hospital every day, and cover the press briefing. Then I would go to the Questura, where they were holding Ali Agca, to see if he would be moved and I could get a shot.

Boy, did this international news newbie learn some lessons! Every day, I would be by myself at the Questura. I would wait, and wait, and wait, and then nothing would happen and I would leave. The guards were amused, shaking their heads.

Then the perp got moved. And the place was packed when I got there! Italian photographers everywhere. Italian photographers with informers on the police force, that is. All the while I was sitting at the clink, waiting for news, these guys were home having wine and a nap, waiting for a call from their guy at the jail. They were plugged in and I was definitely not.

They moved Ali Agca and I got a picture. Along with a couple hundred other guys.

So between a stint in Northern Ireland and now Rome, I had been, as they say, on the road for while, you know what I mean? Every day I had to make a number of calls to the States, and I used the phones at the press area of the Vatican. They always gave me the same operator because she spoke English well. She would get on the phone with her lovely Italian accent, "MacNalli, always MacNalli," she would say. Her voice sounded real nice.

So I mustered the best manly tones I could and asked, "Perhaps we could have dinner?" I could hear her giggling. "Oh, no MacNalli, I have no money!"

No problem, I said, I'll spring for dinner! Ever the gentleman.

More giggling. "Oh MacNalli, you do not understand. We here at the Vatican switchboard, we are sisters!"

I hit on a nun. A new low.

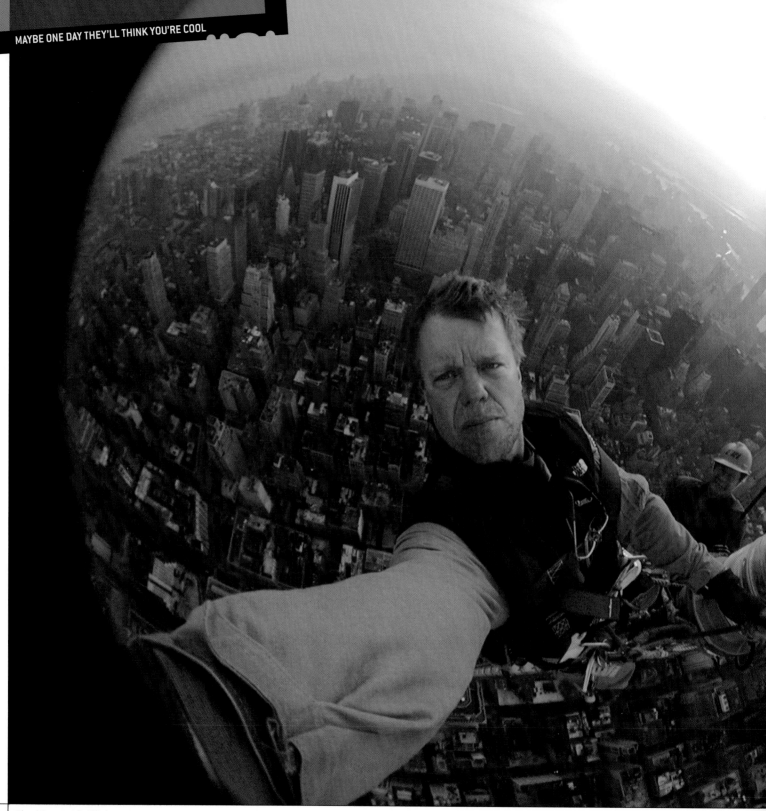

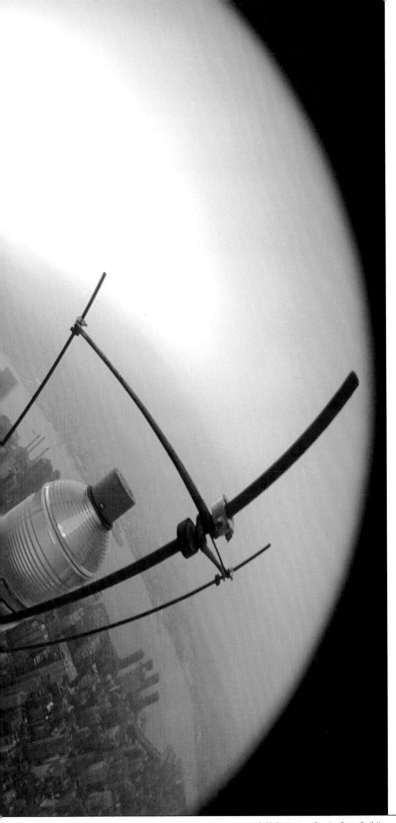

It's tough being a photog dad. You miss a lot of first steps, ball games, recitals, birthdays. When your kids are young, they don't care or understand that you're trying to make a living. They just know that you're gone.

You try to make up for it in little ways. They become travelers along with you, sometimes. They hopefully get a sense that this is a larger world. They (occasionally) think it's cool when you show them a cover or a picture of somebody famous.

And maybe, just maybe, years from now, they'll look up at the blinking light atop the Empire State Building and know that their names are inscribed there.

"Caitlin and Claire…your daddy loves you."

"When your kids are young, they don't care or understand that you're trying to make a living. They just know that you're gone."

Self-Portrait on Empire State Building

McNally Speak: Other Industry Terms

Arc 'im: Good old-fashioned location fun. Sounds like a mob hit, but just involves an older model Speedotron 2,400-watt-second pack, a metallic reflector pan, and a clueless fnugy. Crank the Speedo all the way up to 2,400. I think on the pack by the dial, it simply said "Whammo!" Ask the clueless newbie to put the reflector pan on the head. This would trigger the tubes right when he was basically kissing the light. Pow! Watch him fly! Chuckles all around.

Bag It: Whenever you put a light up, it is advisable to weight it down with a sandbag. It makes the light more secure, safer to walk under, and more inclined to stay upright in a mild breeze. When you don't have the luxury of a sandbag (you know you are involved in a strange industry when you refer to a bag of sand as a "luxury"), you can always use your camera bag or the strobe power pack as a very expensive sandbag.

Bag the S#!% Out of It: When you are in the field, even a bit of wind can mean disaster for your lighting, depending on the size of the umbrella or softbox you've got up there. (Pursuant to Murphy's Law, the size of the light-shaping tool required to achieve the desired effect goes up in direct relationship to how breezy it is.) So, given the possibility of a gust here and there, I usually tell the assistants to "sandbag the s#!% out of it" lest we stage our own version of America's Cup. I lost a 12' silk with the frame, a 12' ladder, and a monster Gitzo tripod into New York Harbor on a shoot with dancer Gregory Hines. Wind came up, tore the silk off the high rollers, and it cartwheeled off the edge of the pier, taking a bunch of my stuff with it. (Thankfully it didn't take Gregory Hines. That would have severely tested the "A bad day in the field beats a good day in the office" theory.)

Biddybastards: These are what get into your gear overnight and screw things up. Ever do a pre-light day in an office or a studio and everything's perfect? You shut down and lock the door, and the next morning it looks different? And not for the better? What the heck? What happened overnight? The biddybastards, I tell ya.

Bites: Bogen Super Clamp, the ubiquitous metal clamp (movie guys call them "mafer clamps"). I tend to call them bites, as in, "Give me a Magic Arm with a coupla bites." Bogen makes a swivel arm called a Bogen Magic Arm, which swings, tilts, and omni-directs all over the place. The clamps are often used to attach the arm to something, like a railing, or a moving vehicle, or some-place you might want to fly a remote camera. So you've got the arm and the clamps. An arm with a Super Clamp at either end is a Magic Arm complete, or an arm with a coupla bites.

C-Stand: Short for century stand, a heavy three-part light stand. Comes in a variety of sizes, although it used to be 100" tall, hence the name "century." Always remember to ask for a C-stand complete, not just a C-stand. C-stand gets you the three-legged base (called a turtle base) and the main column. Bad move. The magic of the C-stand comes from the extension arm. This arm gives you the ability to swing, tilt, and drop a light pretty much wherever you need it, without stuffing the stand itself into the picture and close to the subject. According to Wikipedia, a variant of the C-stand is only 20" at its shortest height; it is nicknamed a "Gary Coleman" stand.

Cheeseball Piece of S#!%: Any expensive piece of photo gear that works at the camera store, works at the studio, and fails in the field.

Chimp: Click, click, click! Ooh, ooh, ooh! That seductive LCD…we stare at it often, a look of wonder on our faces, as if we are auditioning for a part in *Quest for Fire*. Try not to utter hoots, clicks, and grunts in front of the client.

Field of Frame: Means what's in the frame and what's not. I always tell my assistants to let me get a field of frame and then we reverse engineer the lighting

from there. It's not good English and may seem mildly obscure, but on the set, everybody always understands what it means. It's a crucial first step on location. It establishes your field of play.

Flux Capacitor: The standard response when anyone asks you a highly technical, impossible-to-answer, how-many-pixels-on-the-head-of-a-pin-type question about a malfunctioning camera or strobe. "Uhh, lessee, did you check the flux capacitor?"

Fnugy: F-ing new guy. Usually an overeager, intern type who everybody has mild sport with on his or her first days out on location.

Full Boat: All the way up on the pack, as in, "Gimme a full boat on that pack." That means that's all there is and there ain't no more. (Give me everything you've got, Scotty! Jim, have ye gone mad?!!? The engines'll never take it!)

GOBO: Quite literally means, "go between optics." Loosely, I use it on the set to refer to anything that flags off the lens or the light, and helps control spill and flare. It could be a cutter, or a flag, or a piece of cardboard, or your assistant.

Justin Clamp: During the aviation shoot for *National Geographic*, I was clamping small SB flash units to all sorts of aircraft with a real flimsy set of hot shoe clamps. (See "Cheeseball Piece of S#!%.") I complained. (In Webster's, next to "photographer" it says, "he or she who complains constantly.") I complained to my friend Justin, then of the Bogen Corporation, which is the outfit that represents Manfrotto in this country. He came over to my studio with some off-the-shelf Manfrotto parts and cobbled together this little Frankenstein of a clamp. I looked at it and said, "Perfect. Give me 10 of them." Bogen has sold, like, 4,000 of 'em at this writing. And Justin has his place in the world of photo trivia. In the Bogen catalog, the unit is the 175F. But it is listed at B&H as the Justin Clamp.

O.O.: This stands for "overt ogling," or just "oh-oh." It is a common crew affliction on a set where you are photographing a scantily clad fashion model. As the shooter, you can avoid this by keeping both eyes open at the camera. One eye, of course, is in the lens, but with the other you can keep your eye on your assistants and make sure they are watching the lights instead of staring at the talent.

Screw the Pooch: You just shot a billboard job, got back to the studio, looked at your camera, and found out you were shooting JPEG Basic all day long.

Skirt the Light: A black card, or a piece of cloth, or a winter jacket, or a table napkin. Anything you can tape or clamp to the bottom third of the light source to make sure you don't light the feet as well as you've lit the face.

Stingers: Leave it to the movie guys to come up with weird names for common household items. A stinger is an extension cord, plain and simple. The best ones to buy are the yellow ones with little glowing LEDs in the male end. That little light is incredibly valuable, 'cause you don't have to string 50' of cord to your power pack only to find out the circuit is dead. Plug it in. If it glows, you're hot, baby. Ya gotta love the movie folks. They're like a tribe with their own language. I've been renting movie grip gear from Hotlights in NYC for 20 years, and I still don't know the names of what I am asking for. Bob and Dave, the guys who run the shop, are very patient with me. They listen to my description of what I am trying to do, rub their chin for a minute, and say, "Oh yeah, what you need is a 6" cool baby redhead!" "Sure," I reply. I mean, who wouldn't want one of those?

Stitch: Leave little swatches of black gaffer tape on the outer rim of your lens shades—all of them. I call them stitches. Then, when you take the lens out of the bag to use and affix the shade, you can peel one or two of those puppies off and stick/wedge them onto the edge of the shade where it bayonets onto

the camera lens. The shade will be much more secure if you do this. Face it, most lens shades made by most camera manufacturers are basically cheeseball pieces of s#!%. If you bang them into something, they will fall off the lens and into the lake, or worse. Think of yourself quietly maneuvering to get a nice picture of your daughter giving the valedictory speech at her high school commencement. You are getting to a good spot, silently, unobtrusively, crouching all the way, and then your lens shade bangs ever so slightly into the side of a metal folding chair and falls off, skittering noisily across 10 feet of gym floor. All eyes in the gym swivel towards you. The imperious Dean of Students' expression darkens in disapproval from the dais. Another parent retrieves it for you, saying in a whisper, "Here's your shade," but he might as well for all the world have been uttering that phrase made popular on the country cable channel, "Here's your sign," sure evidence that you have just done something irretrievably stupid. Your daughter's face reddens, and she stumbles through the rest of her speech. She is scarred for life.

A Strong Eight: f/8 and a third. I can't get used to the new f-stop nomenclature, like f/9, or f/7.1, etc. Comes from the film days when the manufacturers would sell us ISO 100 that was really ISO 80. If it metered f/8 at 100, you really needed a strong f/8 for reproduction.

A Tic Up: A tenth of a stop. Most power packs now are digital, parsing the f-number into tenths. On the set, a tic up is one click, or one push, on the button.

Underlensed: You've got a three; ya need a six.

VAL: In our current climate of doing more with less (nice phrase for "there is no budget for this job"), as shooters we often find ourselves out there assistantless, and have to dragoon the nearest warm body we can find into holding a piece of equipment, usually light-ing equipment. When you do this, you constantly have to have both eyes open at the camera, one through the lens, and the other on your unknowing, untested, newfound helper, who is doing a rapid series of calculations in his head and arriving at the question many folks ask themselves after they get involved in a photo shoot: "Why the heck did I agree to do this?" Anyway, you need the lights in a particular place, and of course he is wavering, slipping, drifting, yawning, and otherwise waving the light or the reflector around like he is saying goodbye to his kids on the first day of school. You have to constantly coach him, watch him, and direct him: "A little up, little down, come closer, hold steady…." Congratulations! You now have a VAL—a voice-activated light stand.

Valley of the Gels: Colleague Greg Heisler used to refer to this destination. This is where you go when you leave reality behind in the rear view mirror and work for a client who wants you to turn a cubicle workstation with an eight-foot drop ceiling and two 10-year-old PCs running Office 95 into the deck of the Starship Enterprise.

White Light Bleed: When you are careless taping on colored gels over the light sources, this is what you get. It gives you pink instead of red, powder blue instead of deep blue. If you just need a bit of indiscriminate warmth in your light, you can slap on a warm gel without too much precision. But if you want real color, seal the light. Employ this tactic when you are taking a ride into the Valley of the Gels.

Woof: Once you have your field of frame, then you can go woof. Your lights often work best when they are as close as they possibly can be to your subject. The assistant moves the light in, and you have the frame locked down, and the light gets in closer, and closer, and then WOOF! You see the edge of the light. Back off an inch. The light is now as close as it can get.

Zero Out: The cameras nowadays are so bloody automatic, they will give you decent exposures, even if the inputs you are making to the machine are completely wacky. On aperture priority, for instance, your exposures on the LCD will look fine, even though you are shooting at ISO 800 and wish to be at 100. The camera makes the adjustments. It doesn't care about the ISO. (See "Screw the Pooch.") So to avoid this, every morning in the field I ask myself, or my assistant, "Are we zeroed out?" That means we got the camera back to the baseline. My personal baseline is ISO 100, Cloudy white balance, RAW quality (though now, with the D3, I will be shooting RAW+JPEG), and aperture priority. Those are the items most likely to be changed up during the day as we shoot, but that is where we start.

Index

A

B

M